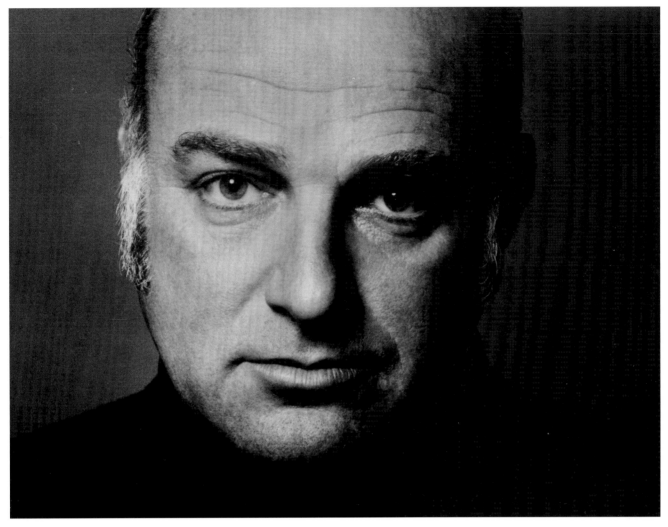

John Schlesinger, 1974

To John Schlesinger, my life partner and my mentor, who encouraged me to be independent and fulfill my creative vision.

To my father, Lloyd Childers, who gave me my first camera when I was fourteen and started me on this extraordinary journey.

—Michael Childers, 2003

INTRODUCTION BY

David Hockney

ESSAYS BY

Christine Giles

Dave Hickey

QUOTE BY

Rex Reed

EPILOGUE BY

Dr. Daniell Cornell

ICONS *and* LEGENDS

the photography of
MICHAEL CHILDERS

To Janice Hall,
with gratitude

Michael Childers

ICONS AND LEGENDS:
THE PHOTOGRAPHY OF
MICHAEL CHILDERS

First Edition:
 Published by Palm Springs Art Museum
© 2004
Design: Lilli Colton Design, Glendale, CA
Printing: Typecraft, Inc.
Wood and Jones, Pasadena, CA

Second Edition:
Published by Michael Childers
© 2012
Design: Stephen Brogdon Design,
Palm Springs, CA

Photo Retouching & Archiving: Jose A. Serrano,
JoseAn Studios, Palm Springs, CA

Printed in the United States of America
ISBN 978-0-615-69147-3

Front Cover: *Natalie Wood*, original photograph 1974,
(detail) © Michael Childers
Back Cover: *Andy Warhol in his New York studio*,
original photograph, 1976
P. 1 *John Schlesinger for Italian Vogue, London*, 1974,
gelatin silver print. British-born director Schlesinger began his
Hollywood film career in 1968 with his Oscar-award winning film
Midnight Cowboy (1969). Other films included *The Day of the Locust*
(1975), *Marathon Man* (1976), and *Yanks* (1979). He was known as
an "actor's director" for his ability to inspire great performances.
Childers and Schlesinger first met in 1968 and were partners for
36 years until Schlesinger died in Palm Springs in 2003.
P. 3: Michael Childers. Photography by Jay Jorgensen.

Library of Congress Control Number - 2012916690

Table of Contents

Michael Childers 11 Artist Statement and Acknowledgments

David Hockney 13 Introduction

Christine Giles 29 Michael Childers: A Biography in Context

Dave Hickey 55 Michael Childers: The Dancer in the Dance

Rex Reed 110 The Glamorous Photography of Michael Childers

Dr. Daniell Cornell 113 Epilogue: Face Value

115 Selected Bibliography

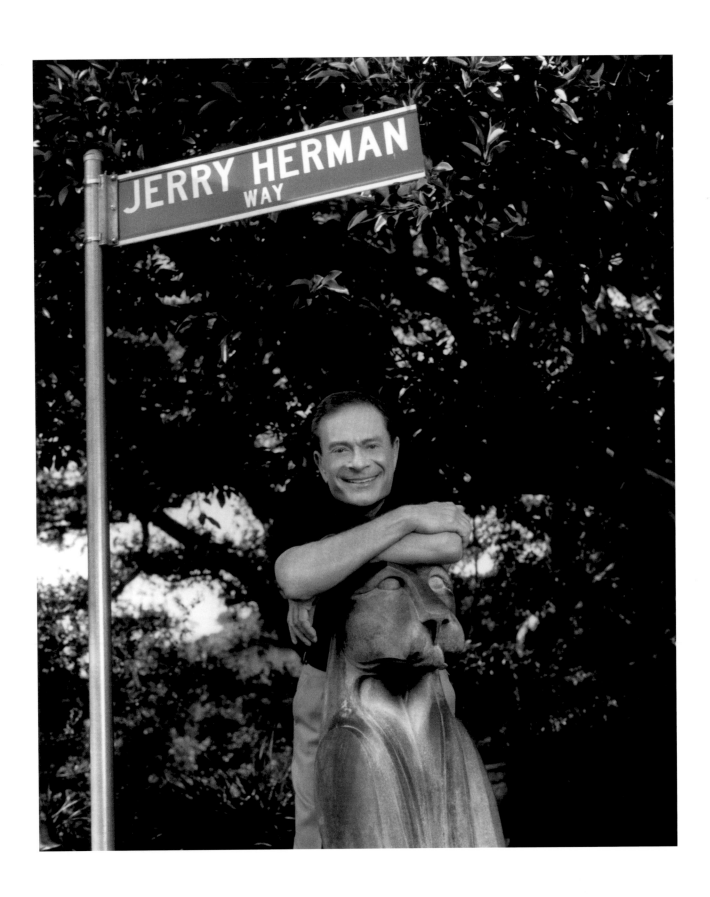

OPPOSITE *Laddie John Dill, Venice, CA, 2003,* C-type print

ABOVE *Jerry Herman, Los Angeles, CA, 2000*

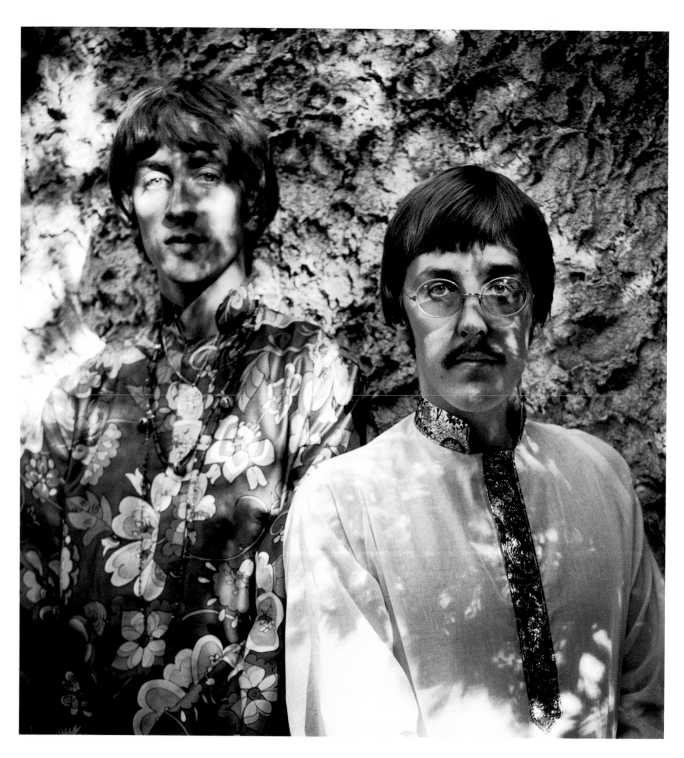

Chad and Jeremy, 1964, toned gelatin silver print

ABOVE *Graham Nash, Hollywood*, 1984,
gelatin silver print

Nash was a member of the famous rock band,
Crosby, Stills, and Nash. Throughout his
career as a musician he was also a photo-
grapher and developed one of the greatest
photography collections in the United States.
Part of his collection was gifted to the Getty
Museum, and other photographs were
auctioned at Sotheby's to raise funds to begin
a new venture—Nash Editions, known for
their innovative developments in digital
photography printing.

RIGHT *Charles Arnoldi's shoes*, 2003,
C-type print

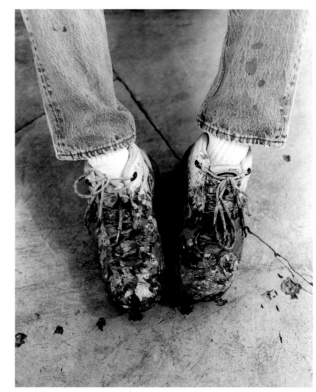

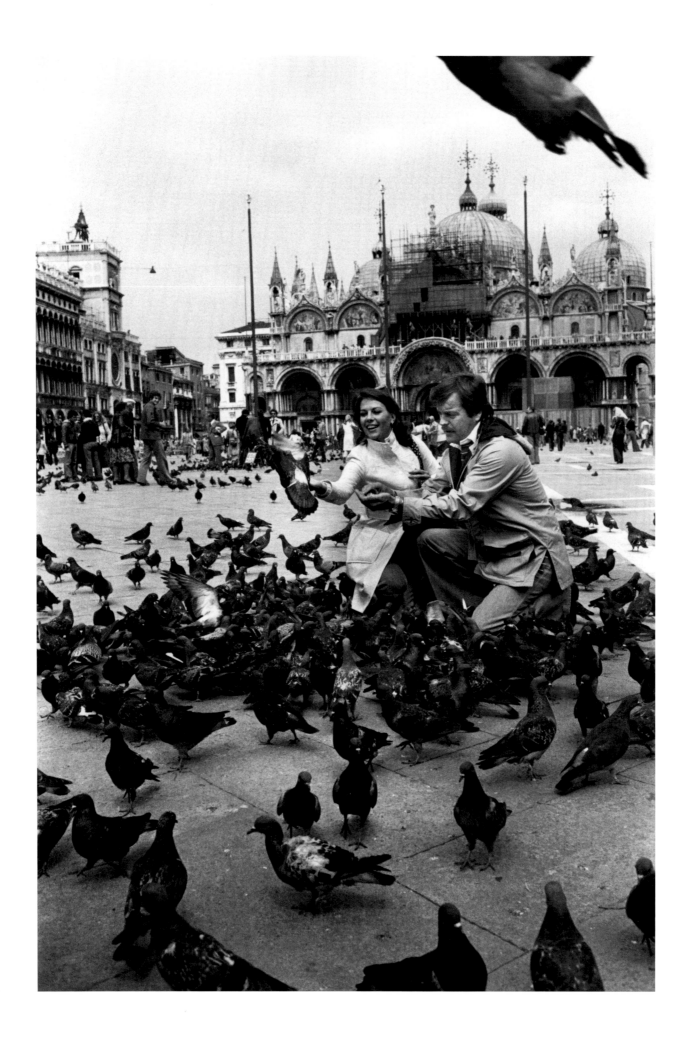

Artist Statement and Acknowledgments

Michael Childers

MY WORK HAS ALWAYS BEEN DIFFICULT to categorize because I never stuck with one genre of photography. There are so many areas that I explore on film—movement with great ballet dancers, explosive moments from great theatre productions, portraiture, nudes, flowers, and interiors among them.

Movies were my childhood passion. They infused my dreams and fantasies. Early in my career I was fortunate to be invited to work for Sir Laurence Olivier's National Theatre in London. This experience allowed me to work alongside and observe some of the greatest acting talent of the last century. Shortly after that I documented the extraordinary explosion of artistic expression in fashion, music, and film in New York City in the early 1970s as one of the founding photographers of Andy Warhol's *Interview* magazine.

In 1970's Hollywood, I photographed a group of unique, young talents with very strong and different personalities who are now our current generation of film legends. The actors would reveal portions of themselves to me during the session—or withhold and be totally mysterious. It is the photographer's job to find the subject's essence—the quality that makes them unique—and then go for the unexpected.

During the 1980s I grew unhappy with the changes that were taking place in Hollywood. With the advent of the celebrity publicist controlling a star's image, there was little room left for a photographer to bring out something special in his subject. I was experiencing a creative block and wanted to move on to other areas to explore fantasy through photography and began concentrating on photographing nudes.

Passionate Moves, a series I started in the late 1990s of couples performing yoga movements, grew out of my passion for dance. I have always loved the human body and its unlimited potential for sensual shapes and forms. With my most recent series, *Distortions in My Mind*, I wanted to take it one step further and explore the psychological. My experience working with actors taught me how to direct models to probe their psyche for the camera. In the distortion images, I am using my own sense of the psychologically theatrical to create a wild ride into the pure pleasure of physicality without limits. Photography is seventy percent voyeurism. I am the observer capturing the moment.

I wish to give a special thanks to Jay Jorgensen for his wisdom and helpful criticism and for his constant and enduring friendship through so many difficult times; and to Tim Bone, my friend and project manager for *Icons and Legends*—without him this exhibition and publication could never have happened.

I would like to thank Marie Chambers for starting me in fine arts photography; Michel Karmen, at A&I Xibit in Los Angeles, for his wonderful prints and selections of my work throughout the years; Don Weinstein and Tommy Dickson at Photo Impact in Los Angeles, for twenty-five years of support; David Hockney, for thirty-five years of friendship; Dave Hickey for his wry and ironic eye; my dear friend of thirty years, Joan Juliet Buck, for her brilliant witticisms—and for making my life in London and Paris so much richer; Conrad Hall and Mary Ellen Mark for sharing their very special vision and for helping me to see; the adorable and supportive Christine Giles, who saw my work in a gallery and said, "Michael, it's your time now;" Louis Stern, of Louis Stern Fine Arts in Los Angeles, for his expansive knowledge of art and photography; Marysa Maslansky, at Visage Agency, for starting my career with the stars in Hollywood; and to my beloved Natalie Wood and her family for years of love and generosity.

Natalie Wood and Robert Wagner in St. Mark's Square, Venice, Italy, 1972, gelatin silver print

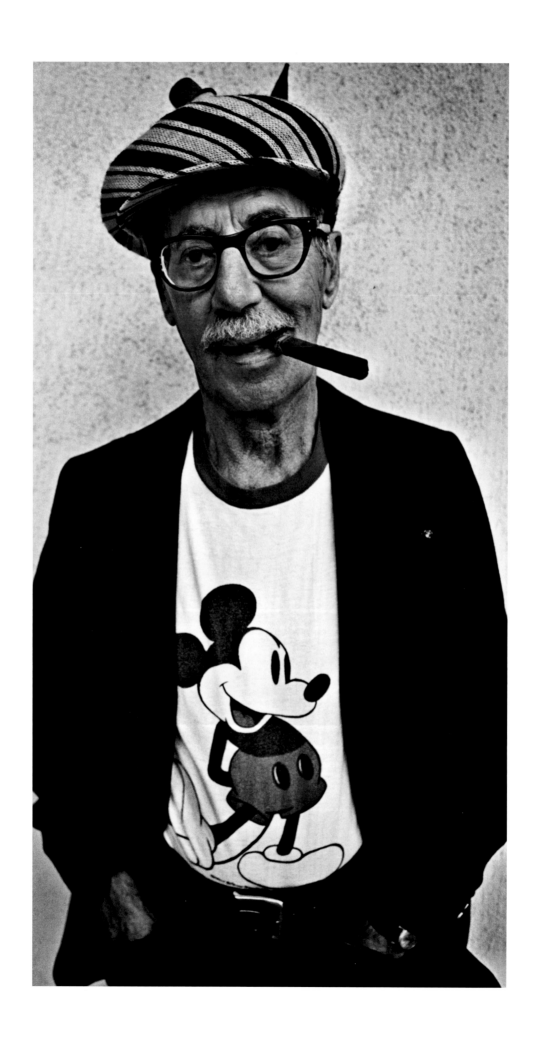

Introduction

David Hockney

ABOUT FOUR OR FIVE YEARS AGO there was an exhibition of portraits of Sarah Siddons at the Getty Museum. They were by Joshua Reynolds, Thomas Gainsborough, Thomas Lawrence, and one or two others.

What was interesting was that no critic or Hollywood actor noticed that we only know about Sarah Siddons, the actress, because of these superb portraits. It is the fate of actors to be forgotten. Performance is *now* and new actors come along. The most famous actors of 1930's films today aren't Greta Garbo or Errol Flynn, they are Mickey Mouse and Donald Duck. Perhaps because they are still alive, or perhaps because they were drawn before they were photographed.

Still images are easier to get to than films. The mass audience wants films about "now," but they mostly disappear. Film is a more ephemeral medium than the still photograph.

So, Michael Childers has recorded beautifully a lot of actors and directors of the Hollywood period he has lived through. He's always to my mind had a droll view of Hollywood, a droll fan you might say. Not the highlighted, slickened (nothing wrong with that though for Hollywood) pictures for the glamour magazines, Childers' photographs are a loving record of people he actually knew and admired. An insider on the edge—a good position to be in.

Being an image maker he was attracted to artists as well and recorded them over the years. We first met in 1968 and have been friends ever since, so I have watched the accumulation of his *oeuvre* over the years. Here is a small part of it telling us of Hollywood and Michael Childers and the artists he knew. Enjoy it.

These will always be his *Icons and Legends*.

OPPOSITE *Groucho Marx at home, Beverly Hills*, 1976, gelatin silver print

RIGHT *David Hockney in his London studio*, 1980, gelatin silver print

The painting Hockney is studying is a portrait of his parents.

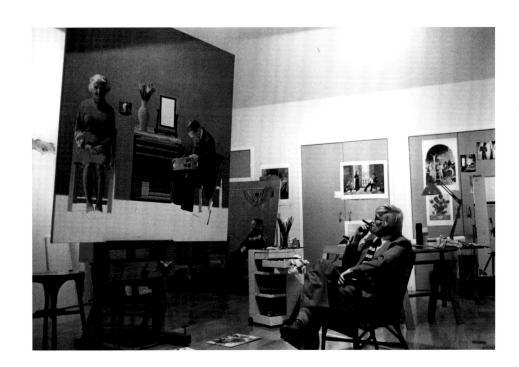

14 *Arnold Schwarzenegger at Muscle Beach, Venice Beach, California*, 1976, gelatin silver print

Already a successful world-champion body builder, in the year this photograph was taken, Schwarzenegger had won the Golden Globe for "New Star of the Year" for his role in the movie *Stay Hungry* (1976).

PAGE 18 *Natalie Wood, Hollywood*, original photograph, 1974

Childers met Natalie Wood in 1968, and they remained friends throughout the rest of her life. He regularly photographed Wood, both for movie productions and in a more casual environment such as at home, as a young mother, with her baby Natasha, and while on vacation with her husband Robert Wagner. Childers produced this photo as part of a series to help recreate Wood's image.

PAGE 19 *Bernadette Peters on the set of "Pennies from Heaven,"* 1981, toned gelatin silver print

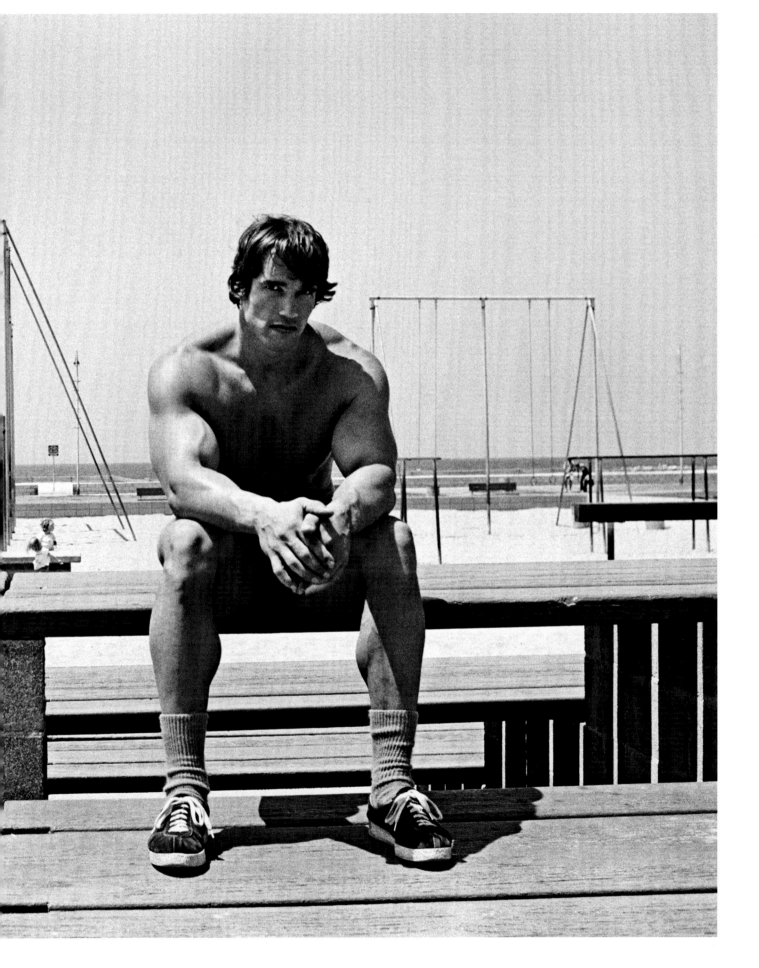

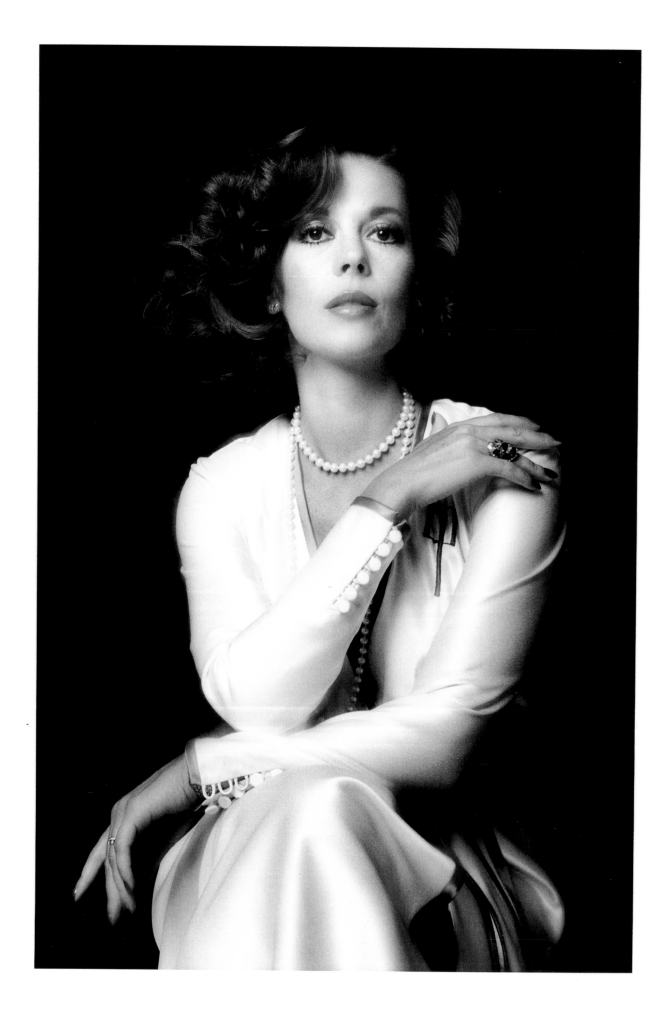

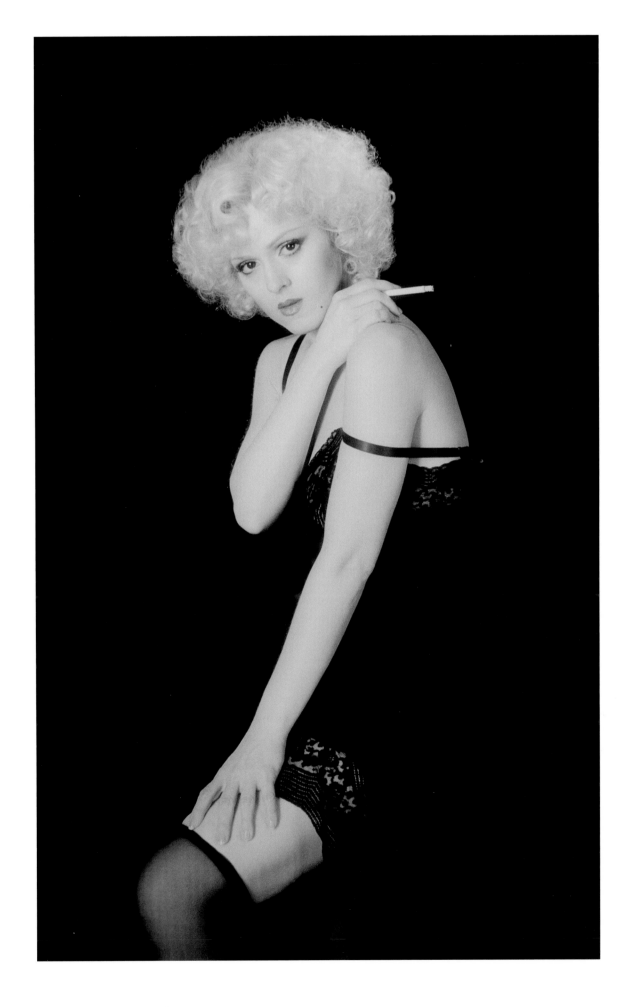

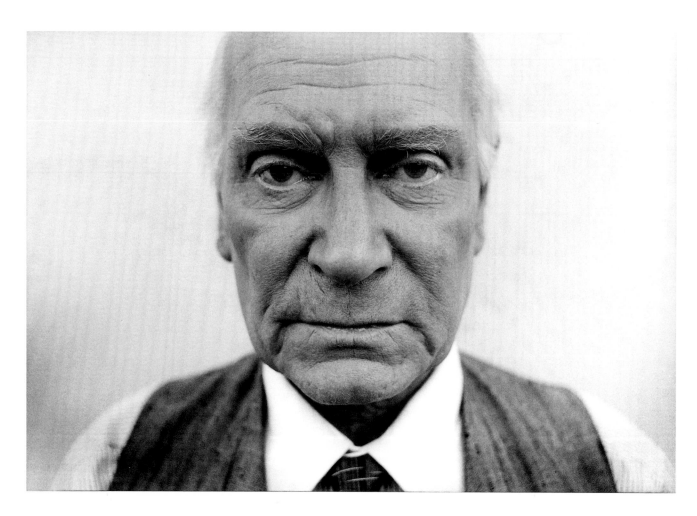

Sir Laurence Olivier, Hollywood, 1975, gelatin silver print

According to Childers, Olivier didn't like to be
photographed. Having worked with the famous actor
years earlier in London, Olivier was comfortable with
Childers allowing him to take this close up portrait.

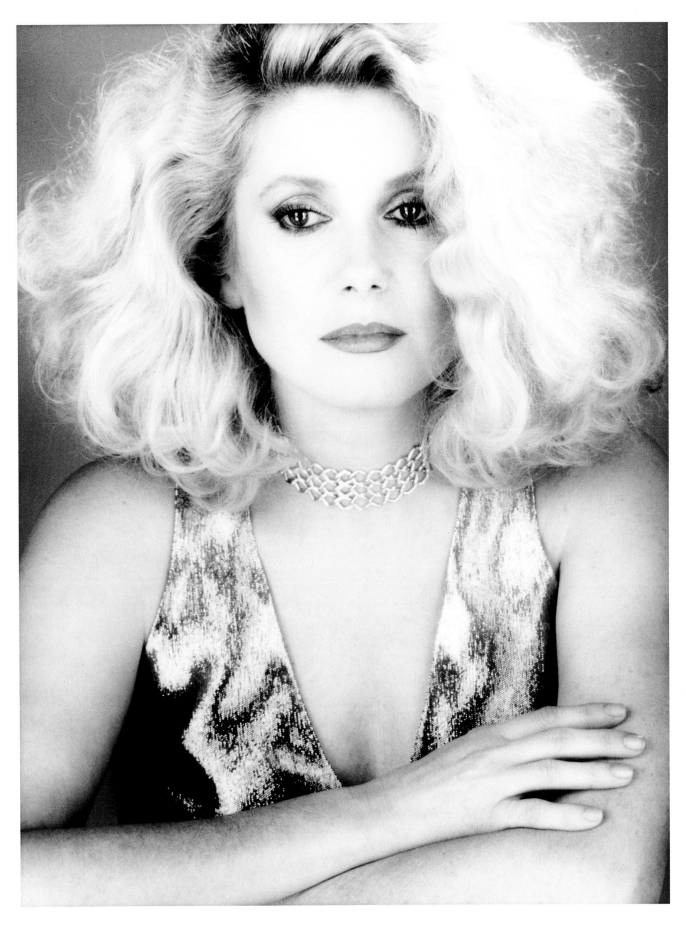

Catherine Deneuve, Hollywood, 1981, toned gelatin silver print

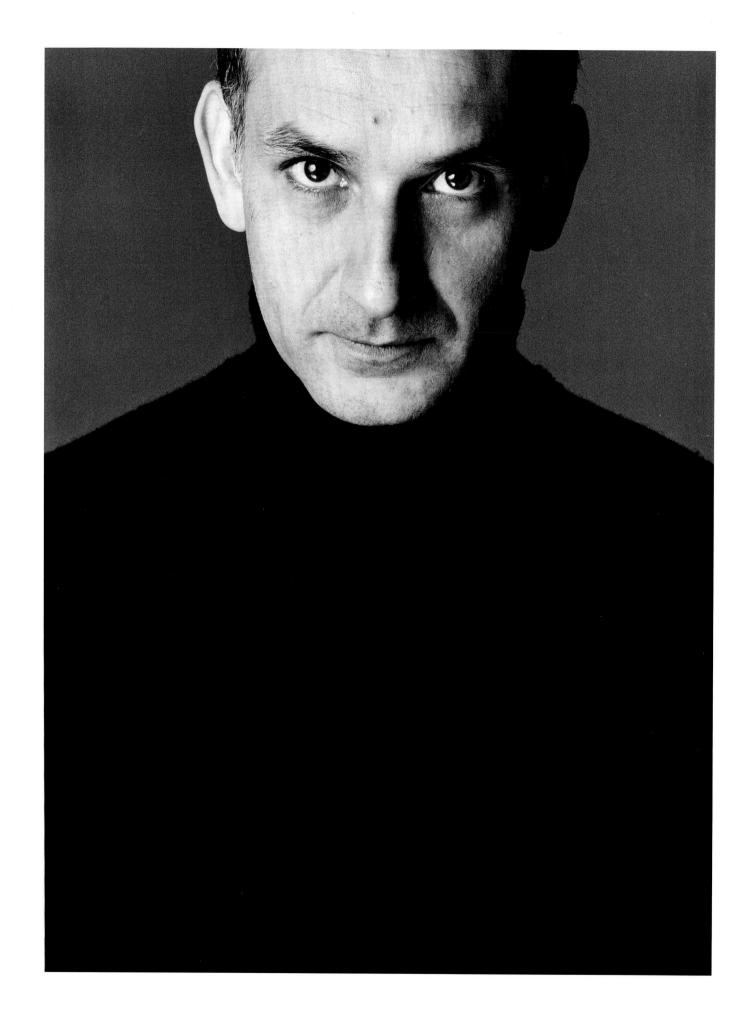

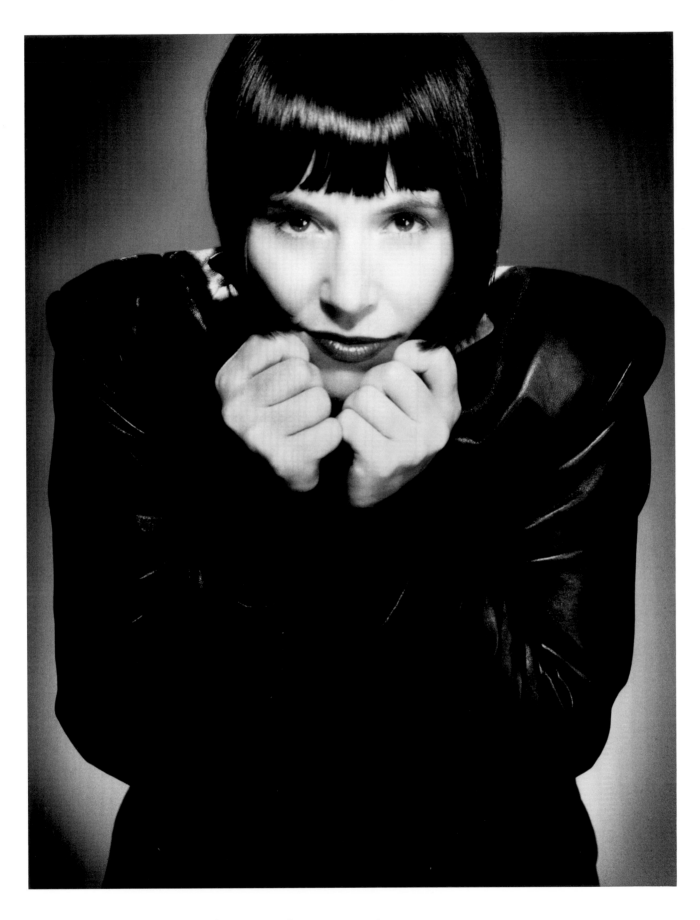

ABOVE *Eve Ensler in "The Vagina Monologues," Los Angeles*, 2001, gelatin silver print
OPPOSITE *Ben Kingsley, Hollywood*, 1990, gelatin silver print

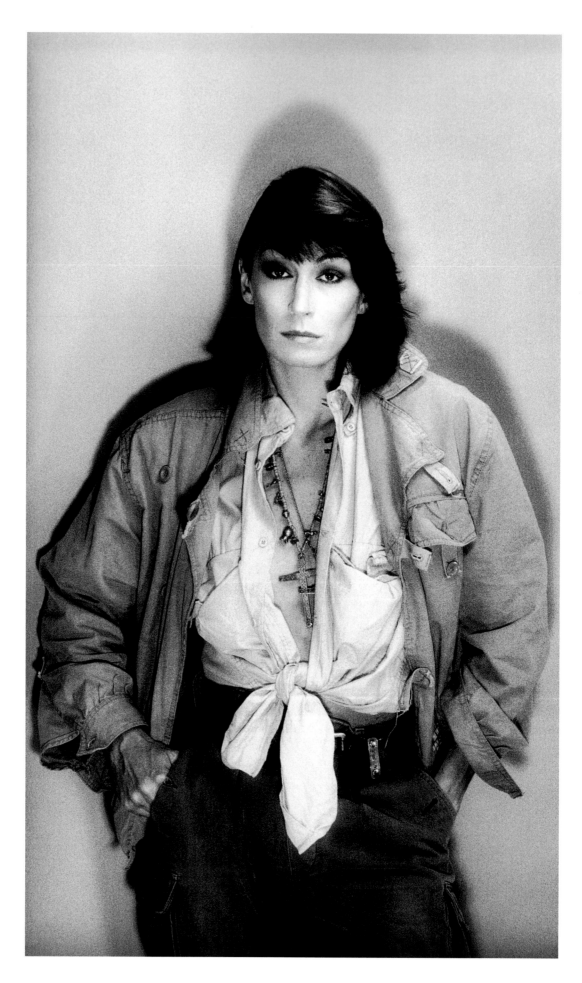

22

RIGHT *Anjelica Huston, Hollywood,* 1980, toned gelatin silver print

OPPOSITE *Carol Channing, Palm Springs,* 2003, gelatin silver print

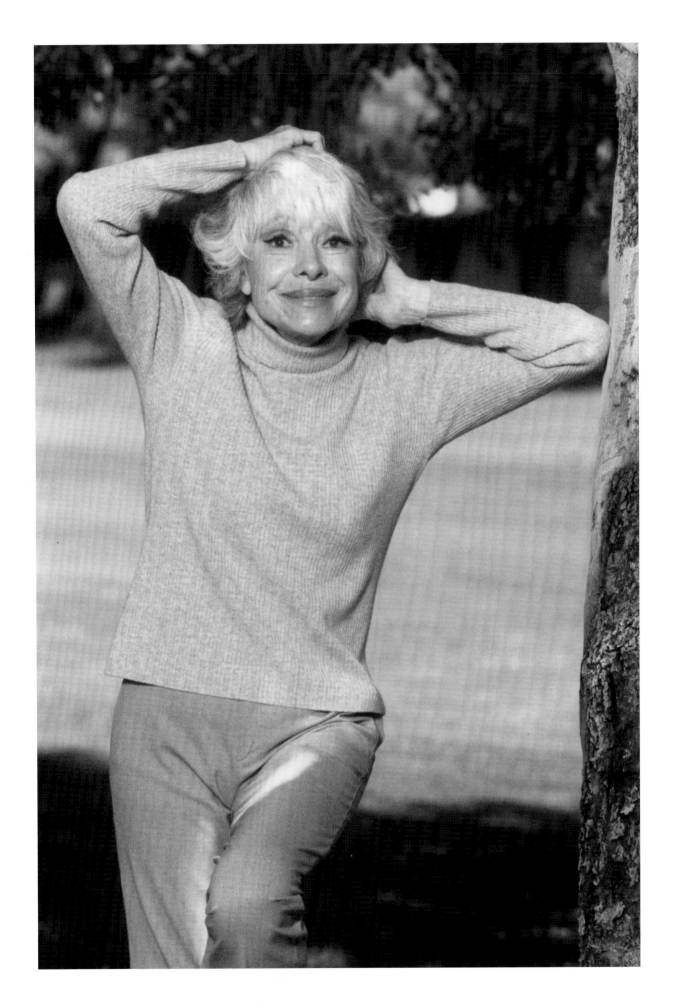

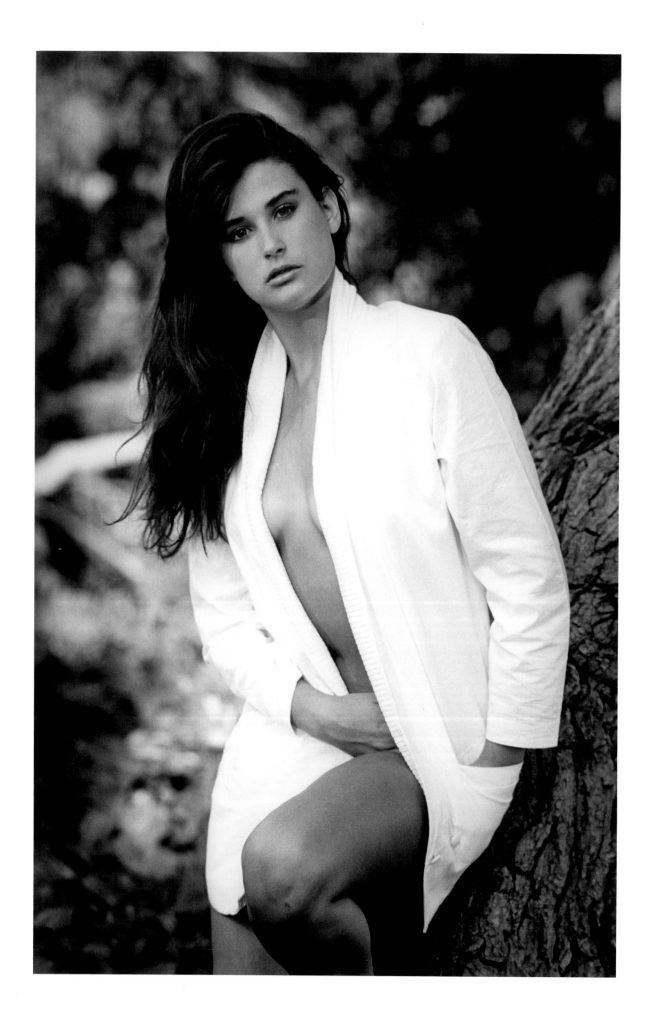

OPPOSITE *Demi Moore,
Hollywood,* 1978, toned
gelatin silver print

RIGHT *Sissy Spacek on
the set of "Coal Miner's
Daughter," Bee, Virginia,*
1980, gelatin silver print

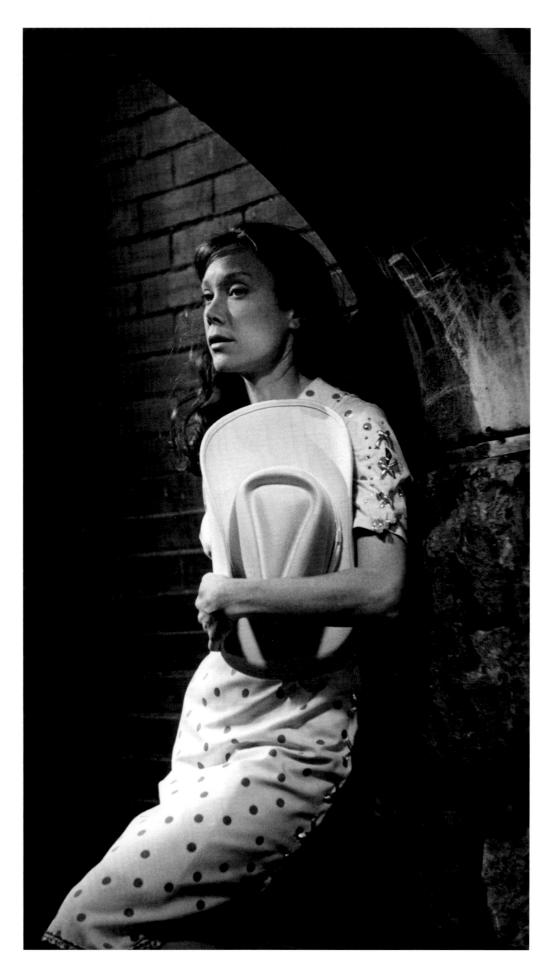

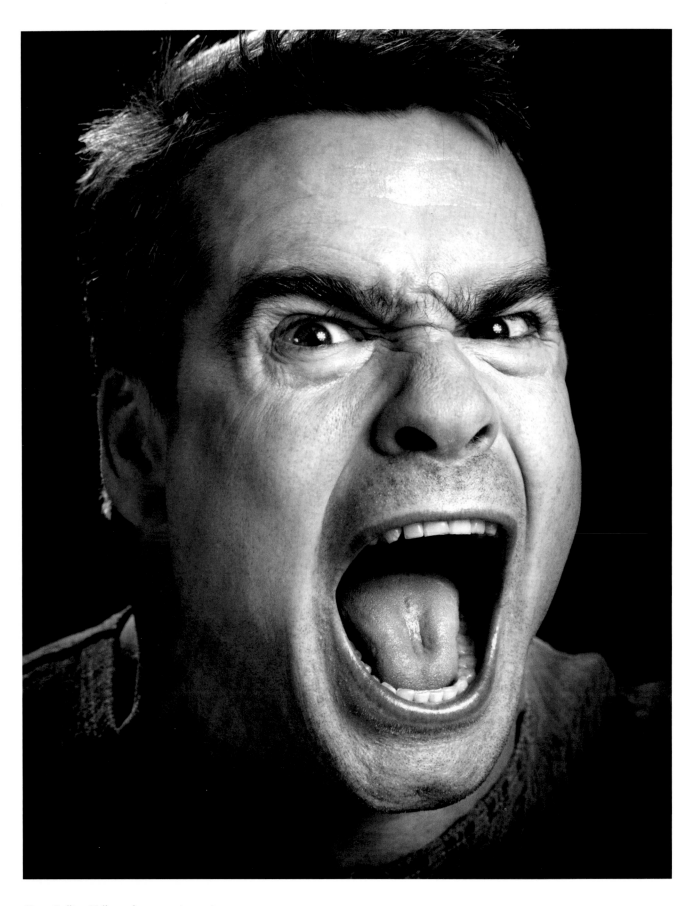

Henry Rollins, Hollywood, 2000, gelatin silver print

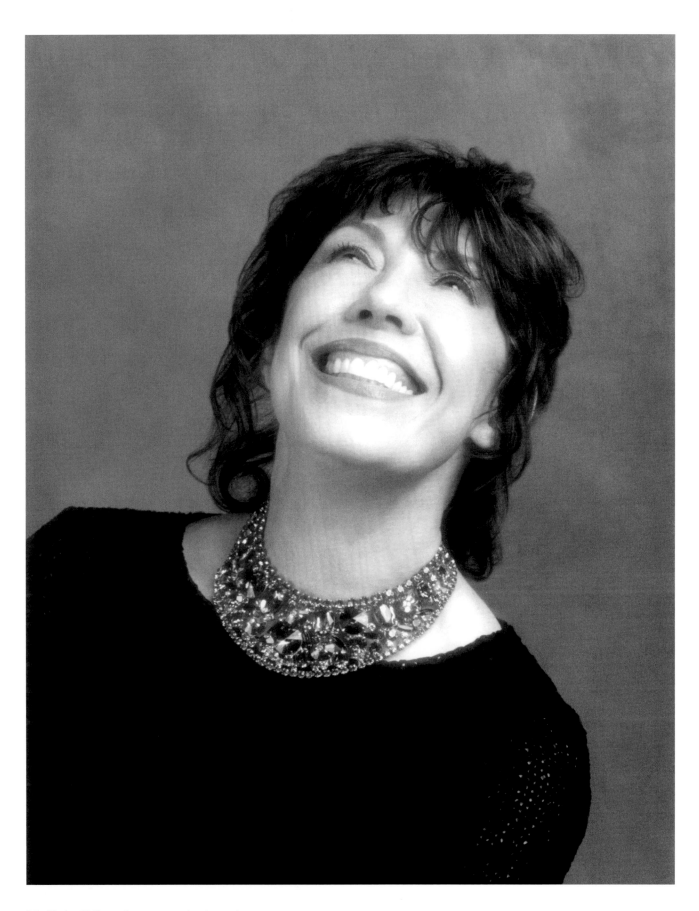

Lily Tomlin, Hollywood, 2003, toned gelatin silver print

Childers met Tomlin in 1976 and they have remained close friends. He is a
great admirer of Tomlin's talent, describing her as "a female Charlie Chaplin."

28

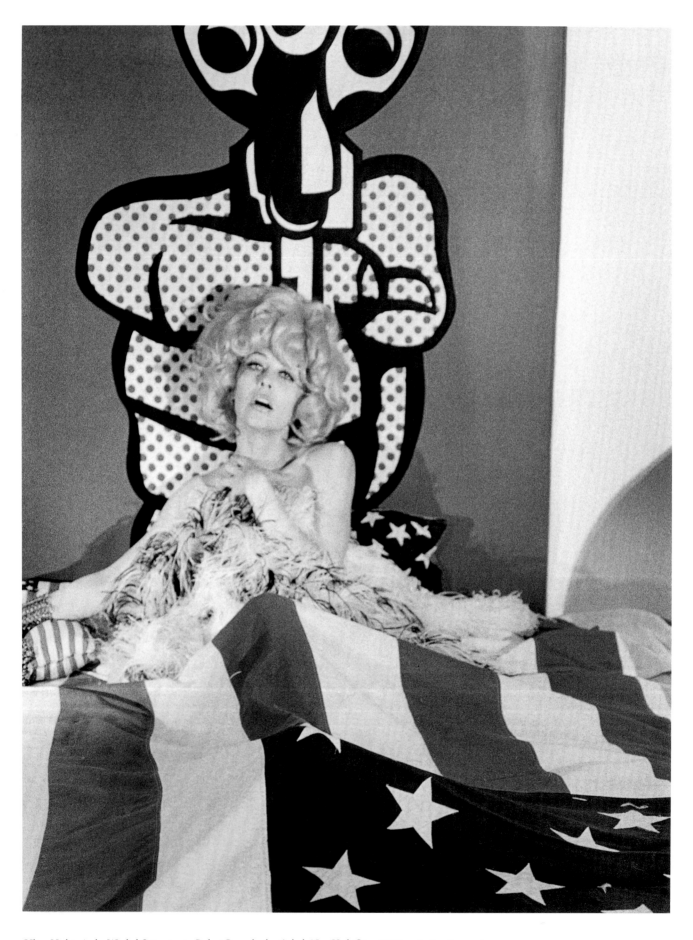

Ultra Violet, Andy Warhol Superstar, in Robert Rauschenberg's bed, New York City, 1968, gelatin silver print

Michael Childers: A Biography in Context

Christine Giles

MICHAEL CHILDERS WAS BORN IN Edenton, North Carolina, the son of Mary and U.S. Marine Colonel Lloyd Childers. In 1958, when Michael was 14, his father gave him his first camera. Before long he was shooting portraits of his friends and providing photographs for publication in the Camp Lejeune High School newspaper. While his two younger brothers decorated their rooms with posters of sports idols, Michael Childers' preferences were magazine clippings of fashion and film photographs by famed photographers Irving Penn, George Hurrell, and others. In his free time, Childers pored over photography books, visited museums and galleries, and went to the movies to see the latest Federico Fellini, Alfred Hitchcock, or Ingmar Bergman film.

After graduating from high school in 1962, Childers moved to California. That summer he found work as a lifeguard for a girl's Christian camp in Idyllwild. Photographing the wooded landscape and taking in the art and music events in the small mountain community filled Childers' off-hours. In the fall he enrolled at the University of California, Los Angeles.

Childers' father had expected him to study business administration; that endeavor lasted four months. Bored by classes, Childers secretly transferred to the theater arts department to study film and photography, which had become a passion. To make ends meet while a student, Childers photographed his friends, most of whom were musicians and actors needing portfolio portraits; two early clients were Rod McKuen and the pop singing duo Chad and Jeremy (*p. 8*). Fees earned in this way paid the bills and provided an immediate reward for his efforts—two practical incentives that encouraged him to turn his love for photography into a career.

By 1960, UCLA had become a major center for art activity on the West Coast, and Childers was exposed to an emerging group of fine art photographers, especially Robert Heinecken (American, born 1931) and Edmund Teske (American, 1911–1996). In 1961 Heinecken introduced photography as a study into the university's fine arts curriculum and a year later he developed a graduate program in Photography.[1] A Los Angeles-based photographer, printmaker, and multimedia artist, Heinecken typically incorporated images from popular culture into his work. When Childers met him in the early 1960s, Heinecken was already well known for his montages—especially of female nudes—and for using a broad range of technical approaches in his work. Today he is considered one of the most important American artists concerned with photographic concepts. Establishing photography as a separate practice in the visual arts, he influenced an entirely new generation of art photographers. Heinecken soon invited Teske to teach at UCLA. Like Heinecken, Teske used a variety of photographic processes in his work, including multiple printing and solarization techniques that lent romantic and dream-like qualities to his photographs. Childers recalls Teske required students to use Mortensen screens in their assignments. Popular with pictorial photographers at the turn of the twentieth century, Mortensen screens were thought to give images an "artistic" character similar to that of painting.

At UCLA Childers also studied filmmaking and enrolled in a class with renowned French filmmaker Jean Renoir (1894–1979), a visiting professor. He recalls that not only did Renoir teach him a fresh way to see and hear by using pre-visualization techniques,[2] he encouraged his students to visualize a film scene *before* filming, instead of focusing solely on the actors' dialogue. To this day, Childers seldom crops his images, but instead uses the full frame of the camera to capture his subject on film.

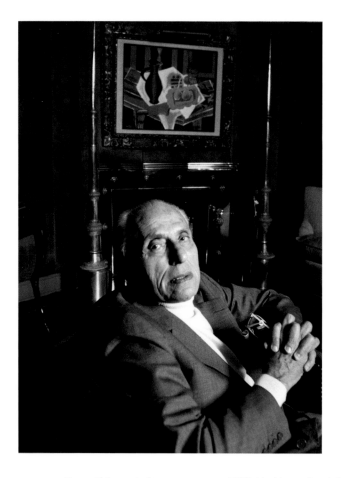

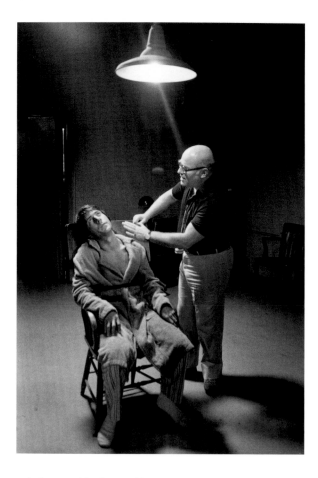

ABOVE *George Cukor with Georges Braque painting, Hollywood, 1978,* gelatin silver print

Cukor, director of *My Fair Lady* (1964) and *The Philadelphia Story* (1940) among many other films, was a collector of modern art including works by Georges Braque, Henri Matisse, and others. Childers photographed Cukor at home, in a room designed by Bill Haines with upholstered suede and molded copper ceilings.

ABOVE RIGHT *Dustin Hoffman with director John Schlesinger, during the filming of "Marathon Man," Paramount Studios, Hollywood, 1975,* gelatin silver print

UCLA's film school has one of the world's finest film archives, and as a student, Childers availed himself of classic 1930's and 1940's Hollywood films. Such film directors as George Cukor and Mitchell Leisen often advised students about their films. With some of the "Golden Era" film legends still residing in Southern California, Childers had opportunities to meet many of Hollywood's greatest starts: Norma Shearer, Agnes Moorehead, Clifton Webb, Claudette Colbert, and Rosalind Russell, among others. One evening, just days after a class in which Leisen had discussed Shearer's films, Childers had dinner with Shearer and friends. Shearer was astounded by the 21-year-old student's detailed knowledge of her films.[3]

Another major influence on Childers' work was celebrity photographer George Hurrell (American, 1904–1992).[4] Childers had admired the luminescent quality of Hurrell's portraits and had been studying his technique since high school. Working from 1930 to 1943 in the major Hollywood motion picture studios, Hurrell is credited with creating the standard for idealized Hollywood glamour portraits. His subjects were some of the most glamorous stars of the time, including Shearer, Joan Crawford, Bette Davis, James Cagney, Greta Garbo, and Jean Harlow. Originally trained as a painter, Hurrell employed fine-art techniques in his compositions, using light and shadow to create intense contrast, mood, and drama—known as the "Hurrell style." While Childers greatly admired the photographs of Penn, David Bailey, George Hoyningen-Huene, Horst P. Horst, and others, he credits Hurrell as the primary influence on his work. In Hurrell's later years, Childers photographed Hurrell with his camera before one of his most popular images of Marlene Dietrich.

"I consider myself lucky," explains Childers. "I arrived in Los Angeles just as the old Hollywood was disappearing." He views this period as a "magical" moment in his life—meeting some of the original film stars and directors from the "Golden Era"—yet these experiences of an earlier era contrasted dramatically with the social and political climate of the 1960s. At the time Childers enrolled at UCLA, the Kingston Trio represented the

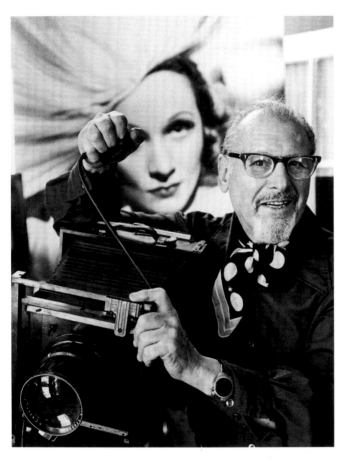

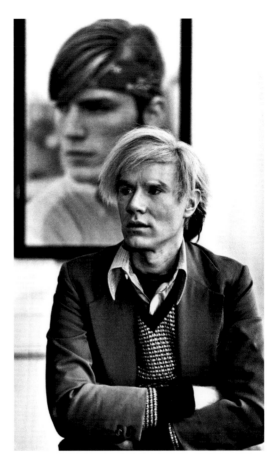

ABOVE *George Hurrell, Hollywood,*
1979, gelatin silver print

Childers admired the photographic
work of George Hurrell and in the
early 1970s they met and became
friends. This photograph shows
Hurrell with one of his famous
images of Marlene Dietrich. Hurrell
once said, "You know, glamour to
me was nothing more than just an
excuse for saying sexy pictures."
(Mark A. Viera, *Hurrell's Hollywood*
Portraits: The Chapman Collection: 1997,
New York, Harry N. Abrams, p. 162.)

ABOVE RIGHT *Andy Warhol*
in his New York studio, No. 1,
original photograph 1976, gelatin
silver print

popular musical style; button-down shirts and short haircuts were the style adopted by
fashionable students. By the middle of the decade, however, the Beatles, Rolling Stones,
Chad and Jeremy, and Bob Dylan were the rage, and suddenly music, fashion, and movies
changed radically. Childers considered himself a "peacenik" and "a bit of a hippie." A long-
haired political activist and war protester at the time, Childers recalls that the Sixties "gal-
vanized the youth of America against the absurdity and injustices of the Vietnam War and
the political establishment of the time."[5] These experiences, and personal changes about
to take place in his life, would contribute to the development of his photography career.

In 1968, within a year after receiving his Bachelor of Arts degree in Film from UCLA,
Childers met filmmaker John Schlesinger (1926–2003), who was to have a major influence
on his life and career. In a relationship spanning thirty-six years, they collaborated in Los
Angeles, New York, London, Paris, and other locations around the world wherever their
film, opera, and theater productions took them. Soon after they met, Schlesinger asked
Childers to assist him on a new film, *Midnight Cowboy* (1969). As a member of the produc-
tion team, Childers created photographic stills and portraits of the actors. He introduced
Schlesinger to the 1960s art and underground culture of New York and Los Angeles,
which influenced several of the scenes in the movie.[6] During the filming in New York,
they often visited Max's Kansas City (a popular art bar) where they met artists Robert
Rauschenberg, Salvador Dali, Larry Rivers, and others.[7] Starring Dustin Hoffman and Jon
Voight, the film won the 1969 Oscar for Best Picture, Best Director, and Best Adapted
Screenplay. Childers recalls his experience working with Schlesinger: "John was an inspi-
ration with his work ethic, discipline, and the way he worked with people. I learned more
in nine months working on *Midnight Cowboy* than in six years at UCLA!"[8] Although he
worked on various theater and dance productions as well, Childers continued working on
film projects with Schlesinger and other directors over the next two decades.

Soon after completion of his work on *Midnight Cowboy*, Childers was introduced to
Broadway theater producer Hillard Elkins. Impressed by Childers' dance and portrait

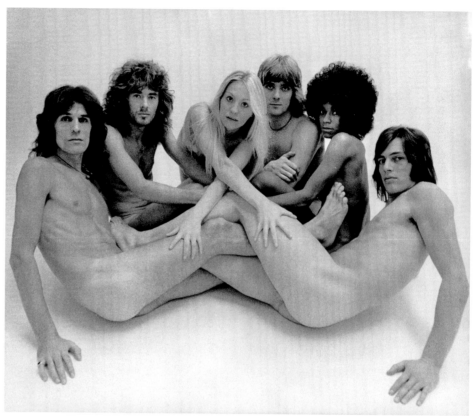

photography, Elkins hired him for a new production called *Oh! Calcutta!* (1969). With contributions from writers Thomas Wolfe, John Lennon, and others, this notorious stage play by Kenneth Tynan broke new ground, featuring full nudity and sexually explicit dialogue. During Childers' photo sessions, the actors and crew insisted that he also strip down, allowing only his tennis shoes and camera. "You lose a lot of inhibitions quickly!" says Childers.

In addition to still photography, Childers worked on the multimedia presentation for *Oh! Calcutta!* using techniques similar to the psychedelic mixed-media performances developed by the Joshua Lightshow in New York.[9] With screens mounted around the stage, fifty-six movie projections with superimposed photographic images fading in and out produced a result that Childers describes as reminiscent of an Edmund Teske photograph.[10]

Kenneth Tynan introduced Childers to the National Theatre in London—then under the direction of Sir Laurence Olivier—where Childers photographed great theater stars including Olivier, Sir Anthony Hopkins, Dame Diana Rigg, Sir Alan Bates, and others. He also worked on *Hair* and photographed Gary Bond for *Joseph and the Amazing Technicolor Dreamcoat* (both premiering in London in 1968). Given that he was the first, and perhaps only, American photographer to work for the National Theatre and was so young, only 26, Childers felt intense pressure to "prove himself" as a great photographer.

After two years in London, Childers returned to the United States and developed his commercial photography career throughout the decade of the 1970s, working intermittently in studios on both coasts—New York and California. He renewed his friendship with Pop artist Andy Warhol and was invited to be one of the founding photographers of Warhol's new magazine, *Interview.*[11] A few years earlier, Childers had photographed several "Warhol Superstars."[12] *Ultra Violet, Andy Warhol Superstar, in Robert Rauschenberg's bed* of 1968 (*p. 30*), is the quintessential image of Pop Art and culture. With an American flag as a bed cover, a languid Ultra Violet leans against a large Roy Lichtenstein banner mounted on the wall above the bed. Entitled *Pistol* of 1964, the image of an oversized hand grasping a gun

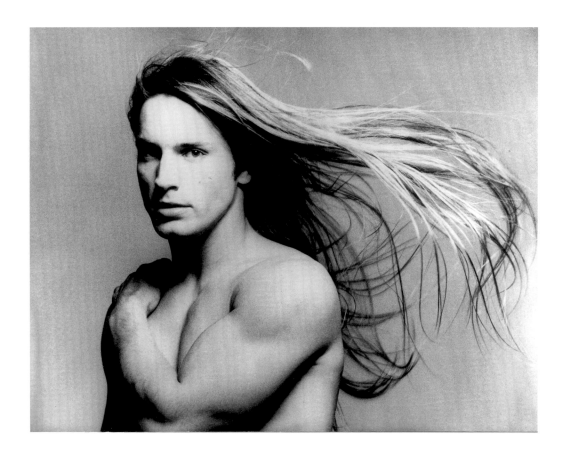

*Joe Dallesandro, Andy Warhol
Superstar, New York City,* 1970,
gelatin silver print

pointed directly out at the viewer presents a powerful symbol in conjunction with the
American flag blanket laid out over the bed below. By contrast, the photograph of *Joe
Dallesandro, Andy Warhol Superstar* of 1970, is representative of high fashion and glamour
showing Dallesandro's muscular torso and long, wind-blown hair. It was photographs like
these that appealed to Warhol for his new magazine. According to Childers, "Warhol did-
n't pay his photographers. You were happy to have the exposure and your photographs
printed as full-page spreads in the magazine. His instructions were, 'Please, only photo-
graph rich, famous, or very beautiful people'."[13]

Childers later made two more important portrait series of Warhol, the first in 1976 in
Warhol's New York studio, and the second in 1980 in Paris, which are believed to be the
only photographs taken of Warhol in his Paris apartment. In *Andy Warhol in his New York
studio, No. 1* of 1976 (*p. 33*), Warhol stands next to an early portrait of the young man he
made into a superstar—Joe Dallesandro. In *No. 5* (*p. 44*) from the same series, Warhol is
seated in a chair wearing a winter fur coat. Taken from overhead, a pensive Warhol looks
upward, directly at the viewer.

In 1974 Childers returned to Los Angeles to work on *The Day of the Locust* (1975)
directed by Schlesinger. He set up a studio on Melrose Avenue and began focusing on
celebrity and commercial photography. Around this time he produced a series of sensual
portraits of Natalie Wood that helped recreate her image. Childers had met Wood in
1968, and they became close friends. He photographed her in numerous movie roles and
also made intimate portraits of her and her family. In his 1974 portrait *Natalie Wood* (*p. 18*),
using black and white film and techniques inspired by Hurrell, a sultry but elegant Wood
gazes confidently and directly into the camera's lens. Childers uses dramatic lighting to
help sculpt her face and highlight her hair, lips, and cheekbones. Wearing a satin dress,
one arm is resting upon her knee, while the other is bent upward to create a sweeping
diagonal movement to the portrait's composition. Inspired by portraits of the silent-film
star Rudolph Valentino, Childers uses a similar romantic style in his 1978 series *John*

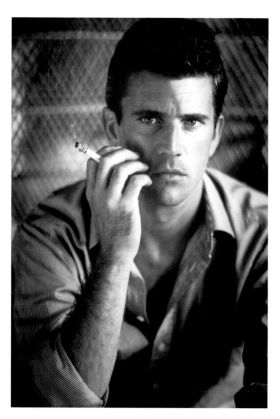

ABOVE *John Travolta as Valentino, Hollywood,* 1977, gelatin silver print

This photograph was taken the same year Travolta starred in *Saturday Night Fever* (1977). Childers developed a series of photographs of Travolta inspired by the romantic images of the former Hollywood legend Rudolph Valentino.

ABOVE RIGHT *Mel Gibson in "The Year of Living Dangerously," Manila, Philippines,* 1982, toned gelatin silver print

Childers met Gibson after he first moved to America from Australia when he was 23 years old. This photograph was taken in the Philippines during the filming of *The Year of Living Dangerously* (1983).

Travolta as Valentino. These and other glamour portraits earned Childers the title, "the modern Hurrell."[14]

Childers enjoyed working with John Travolta and other young stars who had not yet settled on their professional "image." According to Childers, "It was more exciting than after the star has settled on a personal 'look'—which side of the face to photograph, if they're going to smile or not, etc. After an actor becomes popular and settles on a 'look,' the photographer is often locked into producing a set image."[15] Some of the young stars Childers photographed early in their careers include Brooke Shields, Demi Moore (*p. 26*), Mel Gibson, Sissy Spacek (*p. 27*), Richard Gere, and Arnold Schwarzenegger (*pp. 16–17*).

Childers believes that even good photographers fail if they lack the ability to communicate with their models/subjects. Childers learned this skill from experiences in theater work and from watching great film directors, including Schlesinger, work with actors. He describes Schlesinger as a "great actor's director," one who has the ability to inspire exceptional performances in his actors. Schlesinger also had a unique ability to identify and recognize new talent. "He discovered a lot of young talent and turned them into stars," explains Childers. "That also happened when I found Demi Moore and when Mel Gibson first arrived in America. I met and photographed Richard Gere in New York City when he was doing theater, and Tom Berenger was modeling shirts when I recognized his talent and sent him to a movie agent. A great actor has a special presence that we don't have and the camera 'sees' this."[16]

In his photography, Childers also adapted lighting techniques used by cinematographers. The award-winning Conrad Hall worked on several films with Schlesinger and Childers, including *The Day of the Locust* and *Marathon Man* (1976). According to film producer Richard D. Zanuck, "Every film that he [Hall] worked on was something beautiful to the eye, and very imaginative…you could virtually take every frame of his work and blow it up and hang it over your fireplace. It was like Rembrandt at work."[17] Childers spent days studying his lighting technique, explaining: "Conrad Hall is one of the greatest cinematographers in the world. He taught me how to use mirrors and reflection from water.

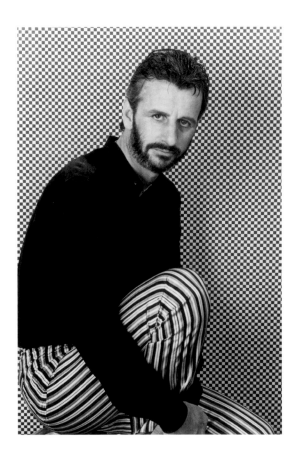

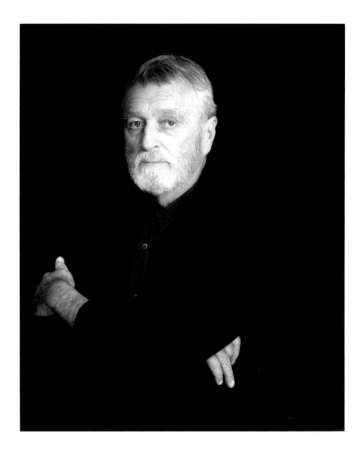

ABOVE *Ringo Starr for Rolling
Stone magazine, Hollywood*, 1980,
gelatin silver print

This portrait was taken the day
after John Lennon was killed,
which no doubt explains Starr's
pensive expression. It appeared
on the cover of *Rolling Stone*
magazine April 30, 1981. For this
shot, Childers used a poster by
British Optical Art painter,
Bridget Riley, for the background.
The checkered background
contrasted with Starr's striped
pants creating a lively, vibrating
visual pattern.

ABOVE RIGHT *Conrad Hall,
Hollywood*, 2000, toned gelatin
silver print

Working with Conrad Hall is like sitting next to George Hurrell or David Hockney. I
stood behind him all day long. I just wanted to see how he did everything."[18]

The goal of fashion and celebrity photography is to create illusions, and *Vogue* maga-
zine and others set the standard for the "fashionable" image. As early as the 1920s, the
opulent soft-focus style still used today was introduced in *Vogue*. By the 1970s, Richard
Avedon and other photographers of high style became major influences on fashion pho-
tography. They combined naturalism and mannerism reflective of the profound changes
in sexual and social mores of the 1960s. Childers combines both these approaches in his
image of Lesley-Anne Down photographed for *British Vogue* in 1980 (*pp. 70–71*), and in his
portrait of Catherine Deneuve in 1981 (*p. 21*) for *Elle*. In most of his celebrity portraits,
however, he offers a more naturalistic image, such as in his 1980 portrait of Ringo Starr
taken for the cover of *Rolling Stone* magazine.[19] Whether for a commercial publication or
for personal interest, Childers' portraits emphasize the faces of his subjects, revealing their
personalities in the process.

The celebrity photography industry changed dramatically in the 1980s. Publicity
managers began to exercise greater control over photography sessions—what the celebri-
ty could wear and how they posed. This interference destroyed the creative process for
Childers. Although he was at the height of his professional career, he had grown weary of
the industry. His interests turned to film production. A *Los Angeles Times* article inspired an
idea for the film *The Falcon and the Snowman* (1985), directed by Schlesinger and co-pro-
duced by Childers. Childers continued to be involved in film production for most of the
1980s, including *The Believers* (1987). He later regretted abandoning photography. "My per-
sonality is not suited to be a movie producer. You're just another cog in a system of a hun-
dred people. For bad or for worse, in photography it's about me: it's you and one other per-
son. It's my vision. In a movie it's the vision of a hundred people."[20]

Early in the 1990s Childers moved to Santa Fe, New Mexico. He returned to photog-
raphy and focused his attention on fine art—or "personal photography" as he calls it—and

ABOVE *Eric Idle*, 1989, toned gelatin silver print

ABOVE RIGHT *Mickey Spillane, Palm Springs*, 2003, gelatin silver print

portraits of artists and friends. He explains: "I discussed the issue of commercial versus fine art photography with Hurrell and Horst. Commercial photography was our job—granted, a fabulous job, but nonetheless a job—and we went to work every day at the studio to produce glamour images for movie posters, albums, magazine covers, or whatever. I had produced somewhere in the range of three hundred magazine covers and thousands of images of celebrities. Some are iconic images and some are of legendary people. Photographing for the Hollywood film industry was like working in a factory with twenty retouchers on staff and a darkroom full of printers. It was a factory!"[21]

Childers felt he had done what he wanted to do with celebrity and commercial work. When he returned to photography, it was to concentrate on his personal interests: fine art photography and portraits of people he admired. Arlene Lew Allen encouraged and exhibited his work in her Santa Fe gallery. Today Childers continues to do commercial work, but he is more selective in accepting assignments.

A personal interest over the years has been photographing visual, literary, and musical artists, as well as architects. The basic elements of a portrait are expression, gesture, lighting, and décor. They are key to revealing the sitter's social class, profession, and psychology, and Childers has mastered these elements to reveal the essential personality of his subjects. For example, in the portrait of author *Mickey Spillane* (2003), Childers portrays more than a likeness including the sitter's attributes as well. Captured in animated conversation, Spillane's black shirt disappears into a black background, which emphasizes his facial expression, arms, and gesturing hands, all symbolizing the essential tools of the writer's profession: his thoughts, voice, and hands. In a portrait of his friend, comedienne Lily Tomlin, her head thrown back in laughter—the same reaction she elicits from her audiences.

While black-and-white photography relies on tone to create a sculptural effect, color may be used to create atmosphere. Childers often incorporates color in his portraits of contemporary artists, as with Ed Moses and his two dogs photographed in the artist's

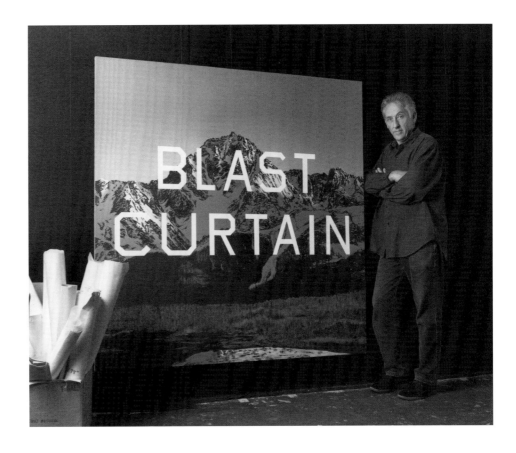

Edward Ruscha with "Blast Curtain," Venice, California, 2001, gelatin silver print

Venice, California, studio (*p. 55*). Seated in an overstuffed chair with beaded designs, Moses' striking white hair contrasts with the colorful setting. Using a double exposure, both upright and sideways, Childers creates an effect similar to Moses' colorful abstract painting style. In each of these examples, Childers has found an essential quality unique to his subject, revealing far more than the outward appearance.

Childers has been photographing David Hockney since their friendship began in 1968. The swimming pool has been a major subject in Hockney's paintings, and Childers wanted to photograph the painter in a swimming pool. The idea for the resulting 1978 photograph, *Hockney at Rising Glen (p. 45)*, was inspired by the French photographer Jacques Henri Lartigue's (1894–1988) portrait *Zissou, Rouzat of 1911 (p. 40)*, in which his brother Zissou, dressed in a suit and hat, sits in an inflated tire tube floating in water. Childers asked Hockney to dress in a white suit and sit in an inflated raft in Childers' Hollywood Hills swimming pool. Hockney appears casual and relaxed. Our eye scans the surface of the surrounding water, and we are drawn to the ball in the upper left corner. Childers also captured Hockney at work by his home swimming pool in Hollywood. In a 1982 photograph, Hockney arranges his Polaroid images into a montage as the two models he's just photographed look on from inside the pool. In *David Hockney in his London studio* of 1980 (*p. 15*), the artist—surrounded in his studio by several large-scale paintings leaning against the walls—intensely studies a portrait of his parents.

Other contemporary artists Childers has photographed include Sam Francis, Edward Ruscha, and Robert Graham; architects Richard Meier and E. Stewart Williams; musicians Cat Stevens, Grace Jones, and Rod Stewart; and writers Tennessee Williams and Christopher Rice.

Always open to new photographic subjects, in the late 1990s Childers developed a series entitled *Passionate Moves (pp. 68–69)* in which he combines a love of dance and human form. In a recent series, *Distortions in My Mind (pp. 62–67)*, Childers uses mirrors to distort images of the human body and reflect light. This process was inspired by the use of mir-

rors in Orson Welles and Jean Cocteau films from the 1940s. In earlier years Childers had studied the distortion photographs of André Kertész (1894–1985), who used a similar mirror technique with nude female subjects in the 1930s. The concept for *Distortions* became clear during a fashion shoot involving mirrors, and soon Childers arranged to have custom moveable mirrors built in his studio so he could begin to photograph the series.[22]

A radical departure from his days as a commercial photographer, today Childers concentrates on the surreal environment of distorted reflections. *Distortions* is the result of what he calls a "liquid abstraction" of movement. Reminiscent of the sculpture of Henry Moore, Childers' forms float in a gravity-free space that appears to have no top or bottom.

Childers has been creating images of icons and legends of our popular and artistic culture for forty years. Yet, when we compare one of his early photographs of Chad and Jeremy taken in 1964 (*p. 8*) with the recent photograph of contemporary artist Jim Isermann taken in 2003 (*p. 10*), we are struck by how each favors a similar Pop Art-inspired style of the 1960s. We are left wondering what really has changed in forty years. Perhaps it is the essential power and mystery of an icon to transcend time, allowing the past to continue to inform and intrigue us. In this particular mental journey, we are guided by the magical photographs of Michael Childers.

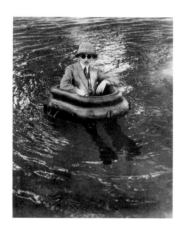

Zissou, Rouzat, 1911, Photograph by Jacques Henri Lartigue, © Ministère de la Culture— France/AAJHL

1. Michael Childers interview by the author, Palm Springs, California, July 2, 2003. Robert Heinecken was a Los Angeles-based artist primarily working with photography and printmaking and a professor at UCLA from 1961 until 1992. Childers remarked on Heinecken's innovative use of photo montages which he developed as early as the 1950s, decades before David Hockney or Chuck Close began their experiments with assembling Polaroid images.

2. Ibid.

3. Ibid.

4. Ibid. Michael Childers met George Hurrell in the early 1970s as they shared the same agent.

5. Ibid.

6. For example, there is one café-scene in the movie where Jon Voight watches a mother and her son play with a live rat. Childers and Schlesinger observed a similar scene during a late-night visit to Fairfax Avenue in Los Angeles.

7. Conversation between Michael Childers and the author, Palm Springs, California August 23, 2003.

8. Ibid, Interview July 2, 2003.

9. The Joshua Lightshow operated in the New York area and was founded by filmmaker Joshua White. They were the "house lightshow" at the Fillmore East for most of its existence.

10. Ibid, Interview, July 2, 2003.

11. *Interview* made its debut in November 1969 under its initial title: *Inter/VIEW: A Monthly Film Journal.*

12. "Warhol Superstars" was the name given to a group of people in Warhol's films.

13. Ibid. Conversation with Michael Childers, August 23, 2003.

14. *Los Angeles Magazine* published an article around 1978 entitled "Hollywood After Hurrell: Michael Childers." A copy of this article is in the Michael Childers' archive.

15. Michael Childers interview by the author, Palm Springs, California July 15, 2003. Most of the information provided in the photo captions was provided by the artist during this interview session.

16. Ibid, Interview July 2, 2003.

17. Kit Bowen, "Cinematographer Conrad Hall Dies," *Celebrity News @ Hollywood.com*, January 6, 2003.

18. Ibid, Interview, July 2, 2003.

19. A close-up portrait of Starr taken during this photo session appeared on the cover of *Rolling Stone* magazine, April 30, 1981. A copy is available in Michael Childers' archive.

20. Ibid, Interview, July 2, 2003.

21. Ibid.

22. Ibid.

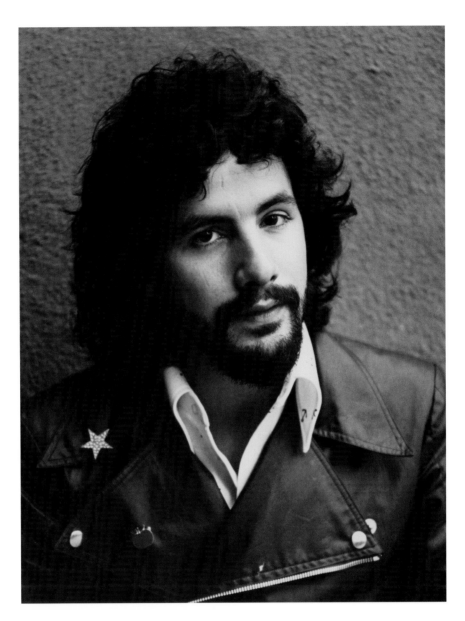

Cat Stevens, 1973, toned gelatin silver print

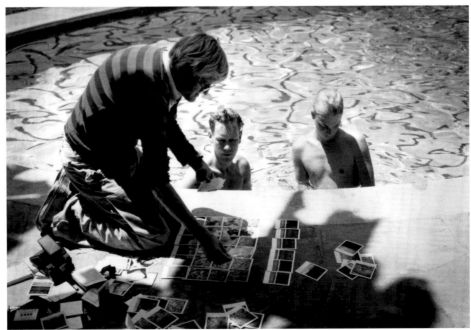

David Hockney at work on a Polaroid montage, Hollywood, 1982, gelatin silver print

On the day this photograph was taken, Hockney described a new idea to Childers, "I've got this new Polaroid technique I'm working on where I break the whole thing up into cubist images." The two men in the pool were Hockney's and Childers' assistants. This photograph shows Hockney assembling a montage composed of the Polaroid images he had just taken as the two assistants/models look on from the pool.

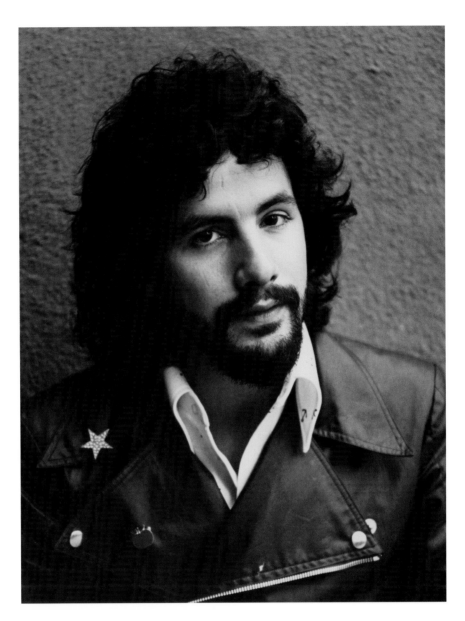

40 *Robert Graham in his studio, Venice, California*, 2003
C-type print

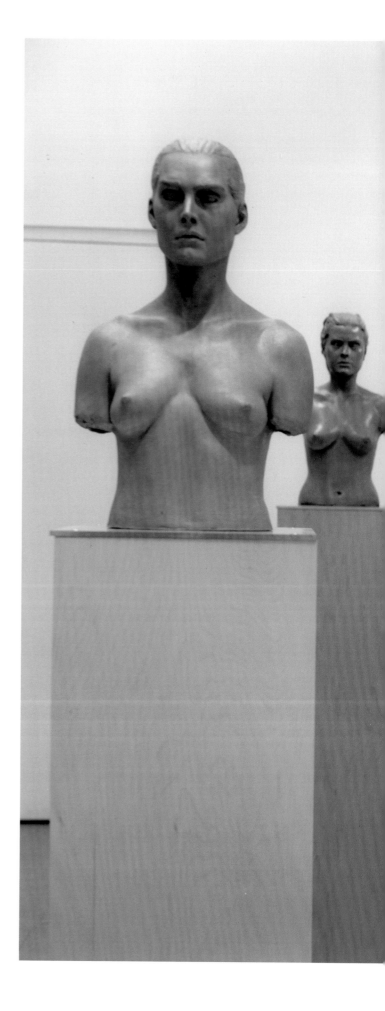

PAGE 44 *Andy Warhol in his New York studio
No. 5*, original photograph, 1976

Childers' relationship with Andy Warhol began
in the late 1960s. Childers took a series of
photographs of Warhol in his New York studio
in 1976, his Paris apartment in 1980, and
several of the Warhol "Factory Workers" or
"Warhol Superstars," as they are known. He
also produced photographs for Warhol's new
magazine *Interview* that premiered in November
of 1969.

PAGE 45 *David Hockney at Rising Glen,
Hollywood Hills*, 1978, gelatin silver print

Childers has been photographing Hockney
since their friendship began in 1968. A
common subject in Hockney's work is the
California swimming pool so Childers
developed the idea of photographing Hockney
in a pool. For this photograph Childers asked
Hockney to wear a white suit and sit in an
inflated raft in Childers' Hollywood Hills
swimming pool.

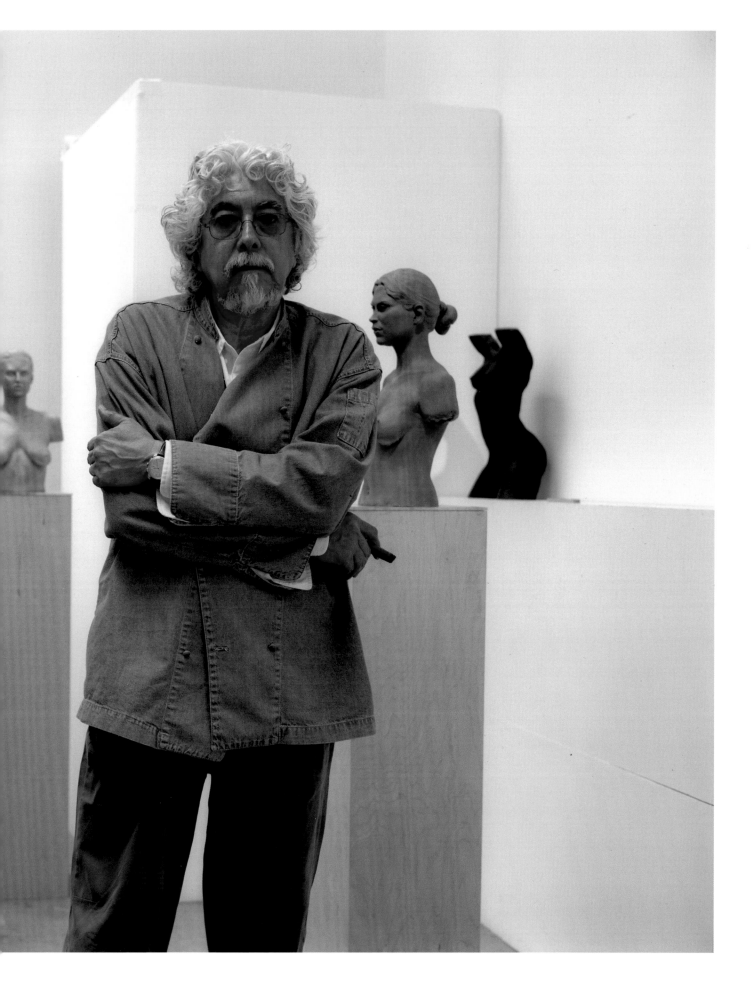

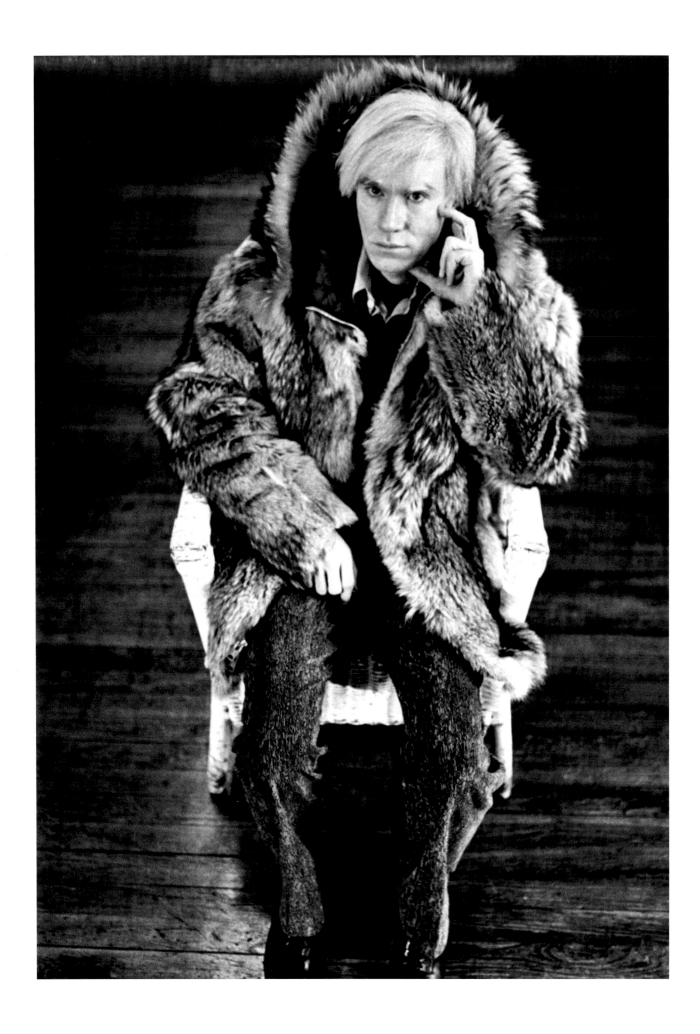

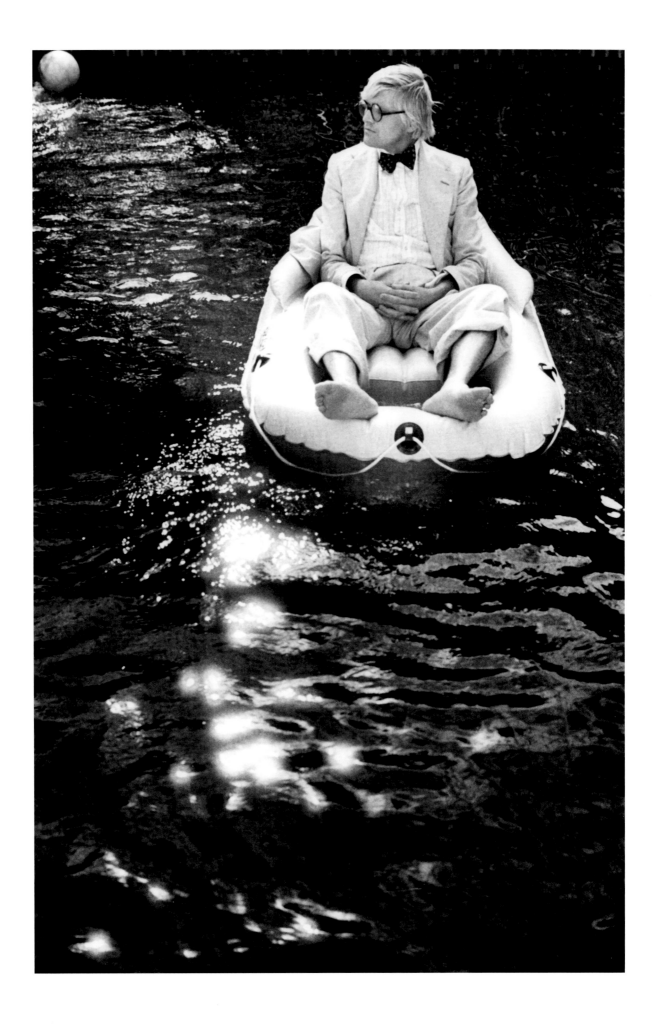

44 *Christopher Isherwood, Santa Monica, California*, original photograph 1984, printed in 2000, gelatin silver print

Childers first met Isherwood in the 1960s and they became good friends. Isherwood was the author of *The Berlin Stories* that were adapted for the popular musical *Cabaret* among other literary works. This photograph was taken in Isherwood's bedroom where he did most of his reading and writing. He was ill when this picture was taken, and about eighteen months later he passed away.

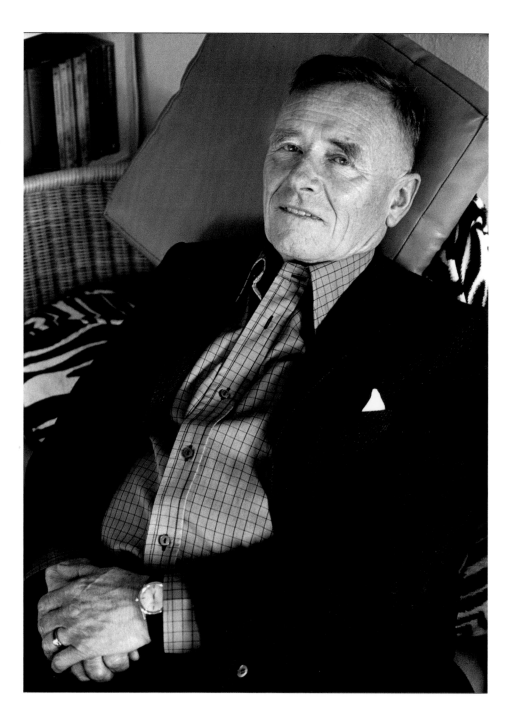

OPPOSITE *Richard Meier at the Getty, Brentwood, California*, 2000, gelatin silver print

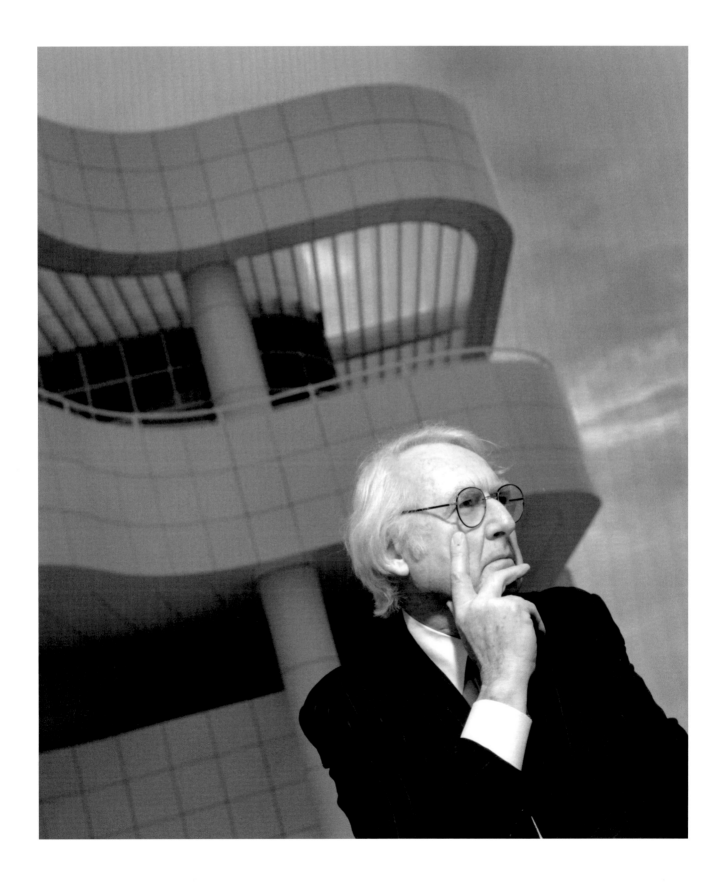

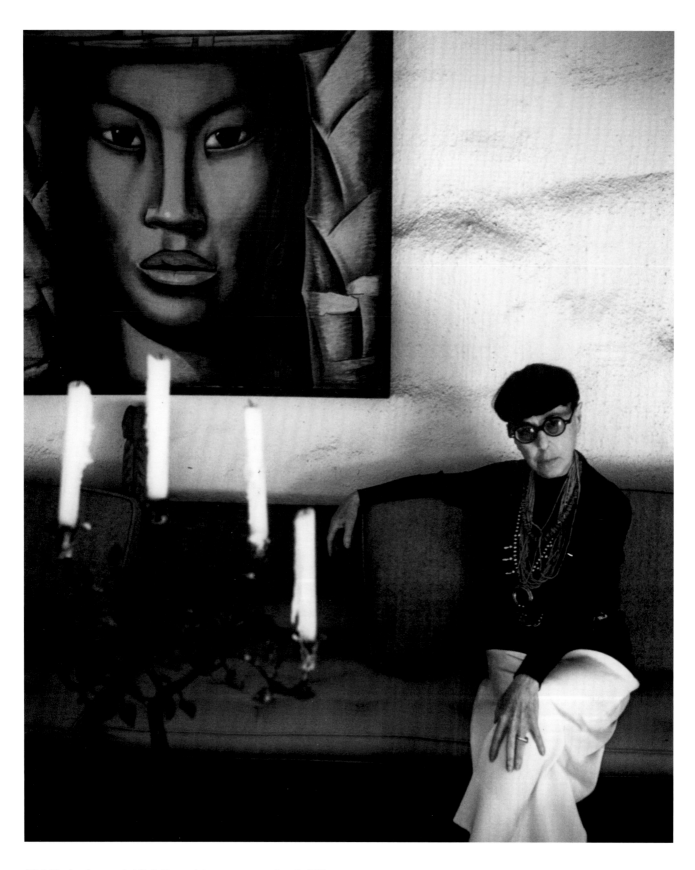

Edith Head at home with Alfredo Ramos Martinez painting, Beverly Hills,
1978, gelatin silver print

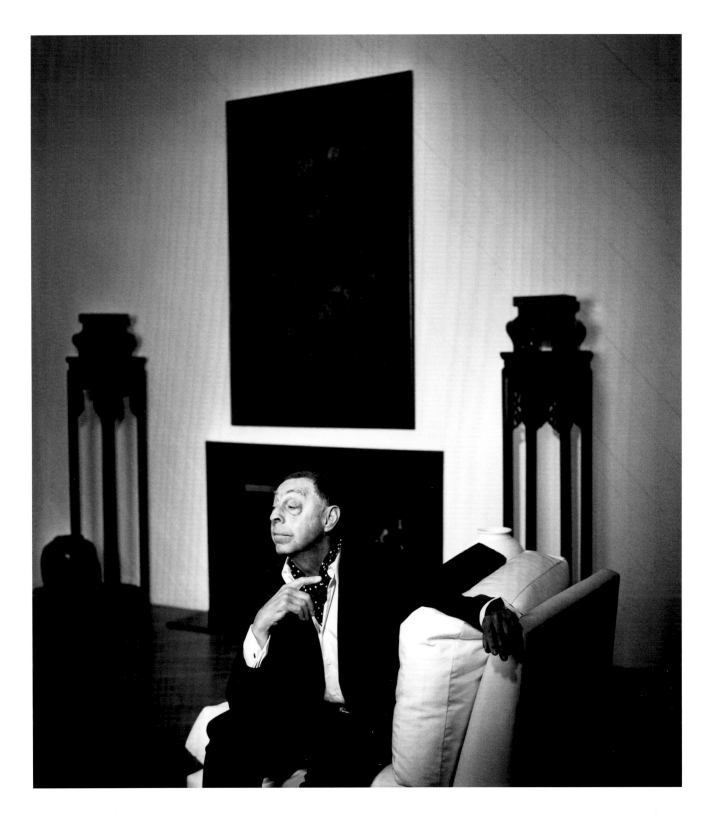

James Galanos, Palm Springs, 2003, gelatin silver print

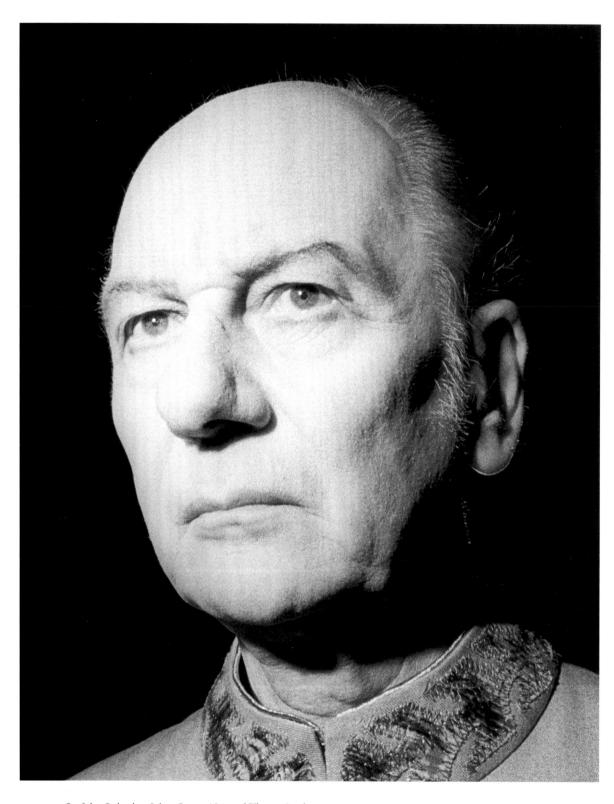

ABOVE *Sir John Gielgud in Julius Caesar, National Theatre, London,* gelatin silver print

OPPOSITE *Tennessee Williams, New York City,* 1973, gelatin silver print

Childers admired Williams as one of the greatest playwrights of the 20th century. This photograph was taken in Childers' New York City studio. Williams lived across the street in one of the few hotels in New York with a swimming pool and Williams loved to swim. Also from the South, Childers describes Williams as having a "liquid southern style."

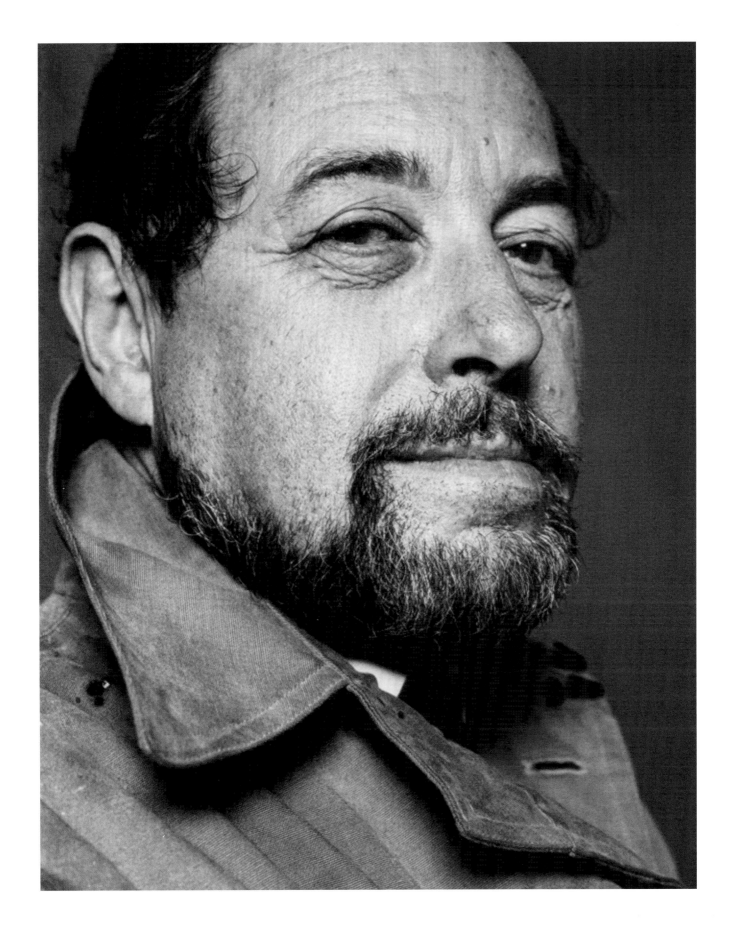

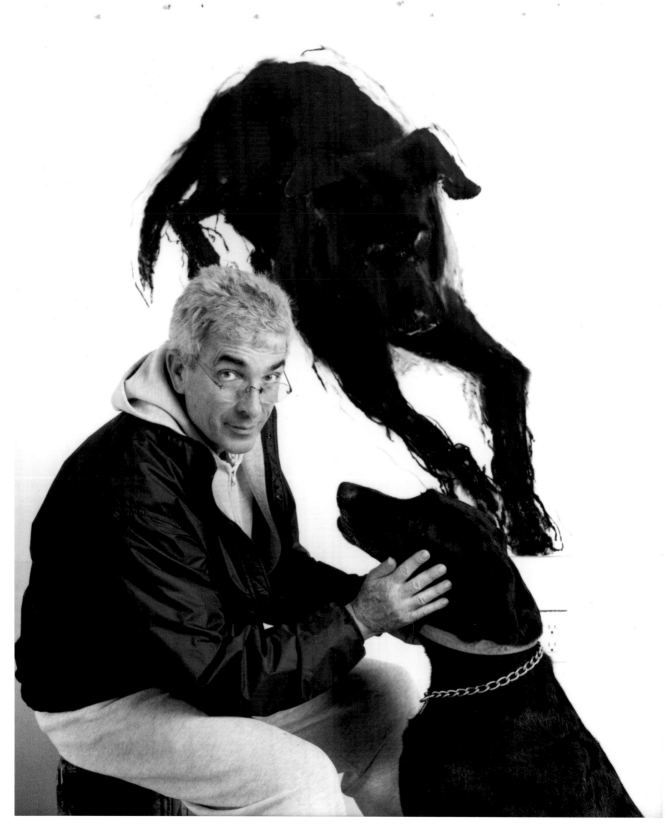

Peter Alexander, Venice, California, 2002, gelatin silver print

Sam Francis, Los Angeles, 1982, C-type print

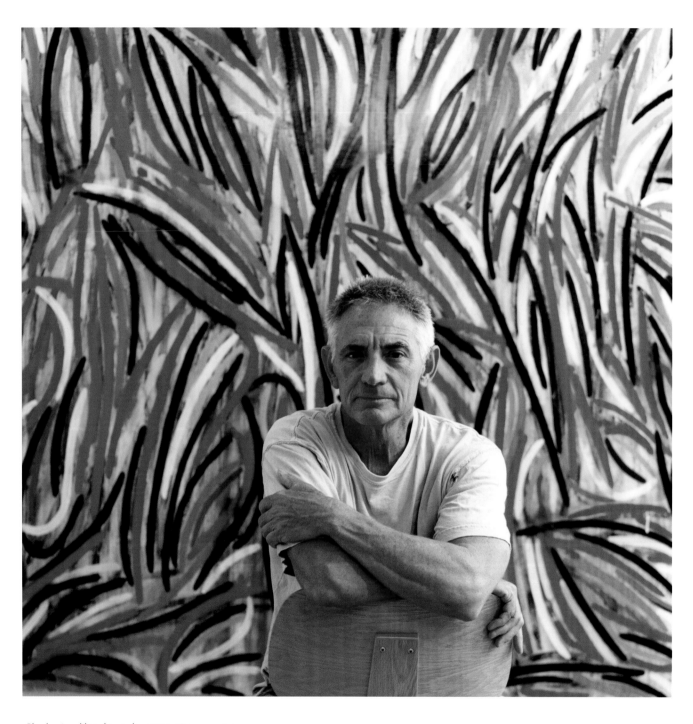

Charles Arnoldi in his studio, 2003, C-type print

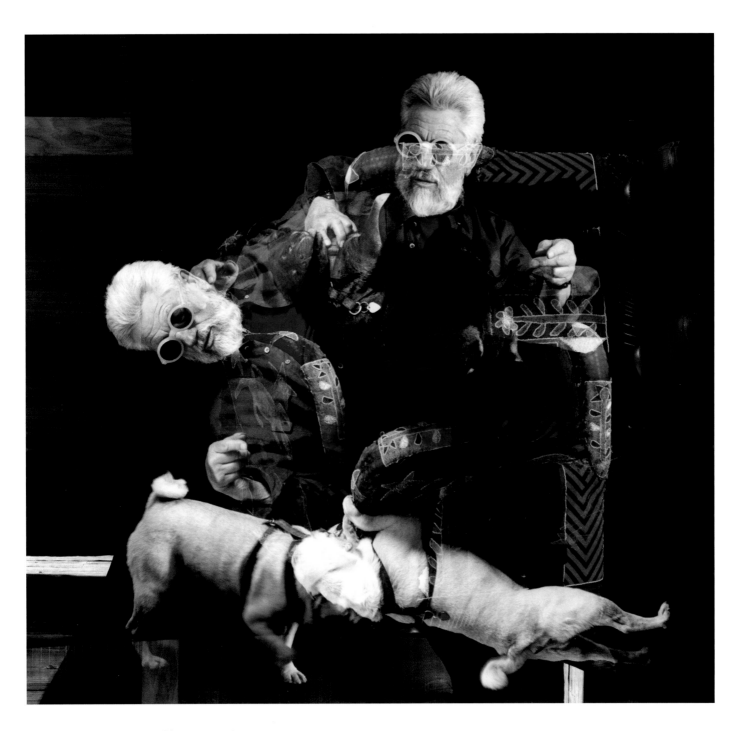

Ed Moses in his studio, Venice, California, 2003, C-type print

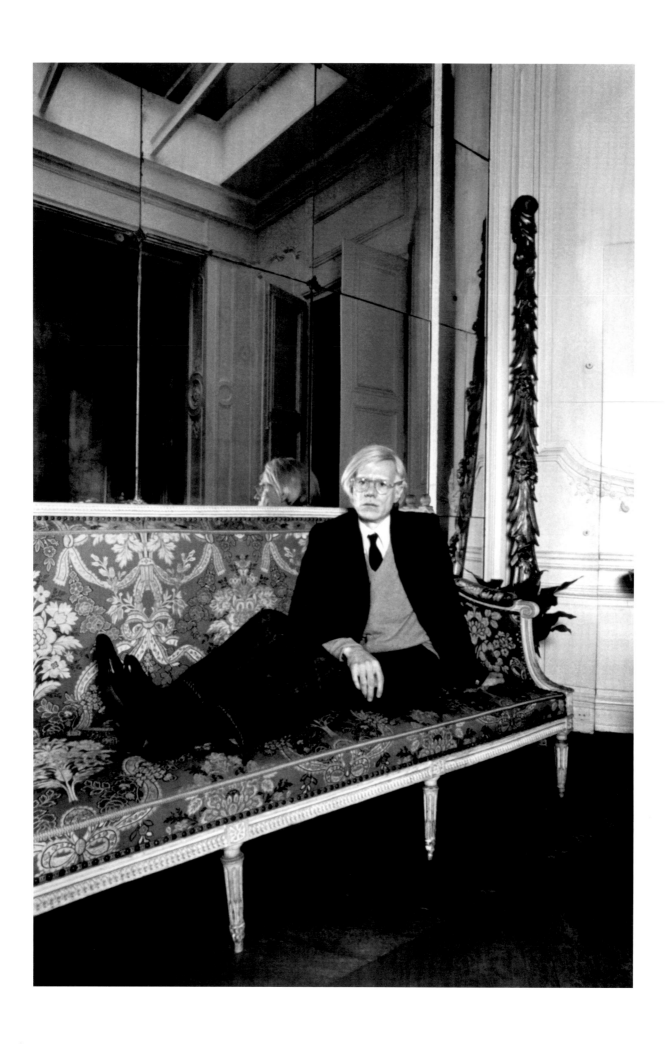

Michael Childers: The Dancer in the Dance

Dave Hickey

The acquisition of my tape recorder really finished whatever emotional life I might have had, but I was glad to see it go. Nothing was ever a problem again, because a problem meant a good tape, and when a problem transforms itself into a good tape it's not a problem anymore. An interesting problem was an interesting tape. Everybody knew that and performed for the tape. You couldn't tell which problems were real and which problems were exaggerated for the tape. Better yet the people telling you the problems couldn't tell anymore if they were having the problems or if they were just performing.

—Andy Warhol, *The Philosophy of Andy Warhol*

DURING THE LAST THIRTY YEARS, a virtual library of books and papers have been published that purport to reveal the aggressive and imperial nature of photography, that seek to designate the camera's lens as a technological extension of the "patriarchal male gaze." During this period, the euphemism that describes a photographer "shooting" a subject has taken on a literal dimension. The camera has become a kind of gun, and it is presumed that the subjects being "shot" are therefore "objectified," dehumanized and robbed of their subjectivity—that the photograph symbolically "possesses" its subjects and, in some interpretations, enacts upon them a kind of visual rape. None of this writing and theorizing, however, takes into account the conditions under which an artist like Michael Childers works. Childers photographs performers and people who work in the world of performance, and, in this milieu, the relationship between photographer and subject is radically altered—as is the presumed social value of the subject's subjectivity.

In Michael Childers' world (which is closer to the world we all inhabit than we usually admit), the power relation between the camera and the subject is reversed. The tables are turned and the putative rape of the subject by the camera is transformed into a romance of mutual seduction. The camera loves the subject; the subject loves the camera; and the photographer is virtually extraneous to this relationship, a third wheel, a beard who uncomfortably oversees a slightly scandalous, intimate romantic encounter. Add to the dynamics of this peculiar *ménage a trois* the fact that Childers' subjects are for the most part entertainers who profoundly wish to please and have the ability to do so, and the affair becomes even more complicated. In situations like this, the photographer either has nothing to do or everything.

As a writer who has spent many years interviewing the people that Childers photographs, I can testify to the complexity of this problem. Performers are trained to mirror the desires of their audiences. Photographers and journalists do much the same thing. They try to mirror their subjects in words and images, and when mirror faces mirror the result is infinite regress. (It is not surprising, then, that when Childers is not photographing performers, he is photographing people and objects reflected in mirrors.) Purportedly, the problem of portraying performers and public people, as it presents itself to the photographer or writer, is how to tell the dancer from the dance—how to distinguish performers from the roles they play in life and art. The difficulty of doing anything like this is neatly demonstrated by a remark of Robert Mitchum's. He is talking about acting in films:

> Here's what film acting is about: The props are real. If I'm on location, shooting a scene where I'm leaning against a tree, the tree is real; the sky behind the tree is the real sky; the ground I'm standing on is real dirt. The clothes I'm wearing are what the character would wear in that situation and they're real, too. If I'm

OPPOSITE *Andy Warhol, in his Paris apartment, No. 9*, original photograph 1980, gelatin silver print

Childers produced a series of portraits of pop artist Andy Warhol in his Paris apartment in 1980. They are believed to be the only known photographs of Warhol in his Paris apartment.

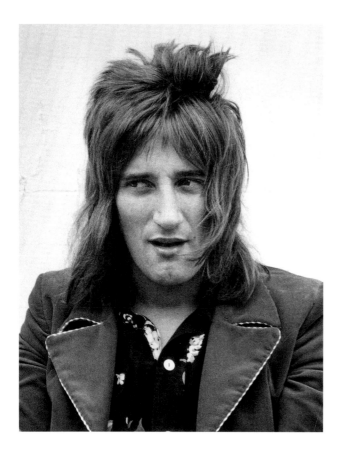

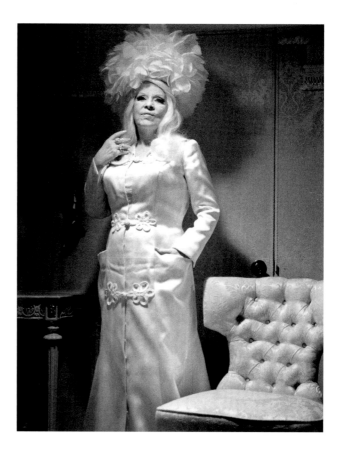

ABOVE *Rod Stewart, London,*
1969, gelatin silver print

ABOVE RIGHT *Mae West on the*
set of "Myra Breckinridge," Twentieth
Centrury Fox Studios, Hollywood,
1969, gelatin silver print

This portrait was taken during the
filming of *Myra Breckinridge* (1970)
in a dress designed by Edith Head.
West would have been about 78
years of age; however, she was
never quite truthful about her
age, so it is difficult to confirm.

carrying a gun, which I often do, it's a real gun. Everything is real, in other words,
except me, my character. That's fake. It's a made-up person. So you have to use
the audience's belief in the setting and the props to make the character real. I'll
give you an example: Most actors handle guns on screen like they're cap pistols
or they blow bubbles. They are real guns, of course, but the actors make them
fake. They forget that it's a real gun because they're in a movie. You can't do that.

The consequence of this actor's trick, the one that Robert Mitchum does not address,
is that actors, while recruiting the environment to validate their fictional characters, fiction-
alize the environment itself, and any performer with the skill and charisma to do this, does
it all the time, onstage and off. If I am sitting in a diner in Muscle Shoals, Alabama having
breakfast with Rod Stewart, he is in the movie. I am not. Stewart is always in the movie.

The traditional solution to the problem of getting the actor out of the movie, of
telling the dancer from the dance, has been to exacerbate the aggression of the camera.
Yousef Karsh does this with baroque lighting and sharp focus lenses that turn faces into
lunar landscapes. Weegee (Arthur Fellig) steps up the aggression with distorting angles
and lenses. Robert Mapplethorpe does much the same thing by assaulting his portrait sub-
jects with a blazing white magnesium flash. All of these devices add an element of tech-
nological neurosis to the romance between the camera and its subject, but they do not so
much reveal the subject as reclaim the photograph for the photographer. They take the
photographers' subjects out of their own world and place them, not in the real world
(whatever that is), but in the photographers' own private visual domain.

Michael Childers' photographs embody a shrewder and more subtle approach to the
dancer-dance-problem. Rather than devising technical solutions, he calls the problem
itself into question. The basic assumption of the dancer-dance-problem is that we all have
autonomous "inner selves" that are different from our "outer selves" and are, in fact, our
"best" selves and our "real" selves. Consequently, photographers and writers who are
charged with portraying us have an obligation to reveal this "inner self." Unfortunately,

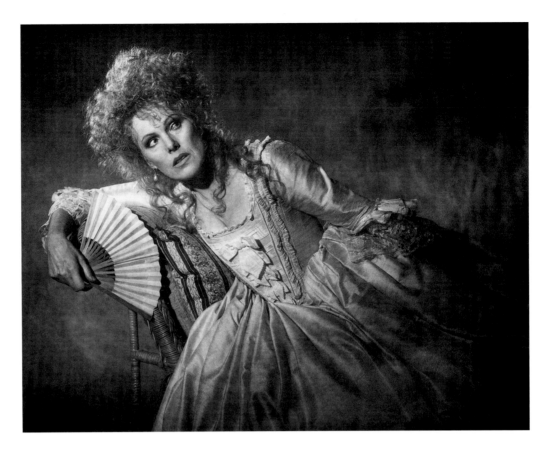

Lynn Redgrave in "Les Liaisons
Dangereuses," Los Angeles, 1988,
toned gelatin silver print

neither the existence of that "inner self," nor the artist's responsibility to reveal it, are much more than popular fantasies. This is the point of Andy Warhol's "Parable of the Tape Recorder," which is quoted above.

Part of what Warhol's parable implies, of course, is simply a truism that the responsibility of working in the world mitigates our emotional self-indulgence. The subtext of the story, however, is more profound, and profoundly American. Warhol is, in fact, suggesting that, as citizens of a representative democracy, we all have the right to be represented, not just by congressmen and lawyers, but by cameras and tape recorders as well. This is the subtext of Warhol's observation that, in the future, we will all be famous for fifteen minutes. He wants us all in the movie, because, for Andy, MTV's "Real World," is the real world. His inference is that we are redeemed by representation, that our inner lives, insofar as they exist, are less important and less "real" than we imagine them to be, that we live best and most happily in the external, social world among our fellow citizens, in the theater of democratic public life. So our job is not to be ourselves, but to perform ourselves for one another and, ideally, for the camera or the microphone, because these devices socialize us; they make us aware of our performance and of our audience. Thus, self-expression, when it is being recorded, breeds self-consciousness, and self-consciousness mitigates narcissism by putting things into proportion, by transforming inner drama into public theater.

Michael Childers, taking this page from Warhol's book, lets his subjects perform themselves, or catches them between roles, performing themselves in the regalia of being someone else. His photographs of John Travolta as Valentino (*p. 36*), of Bud Cort as Orson Welles, of Mae West in *Myra Breckinridge*, Marilu Henner in *Hammett*, and Lynn Redgrave in *Les Liaisons Dangereuses*, all execute this rather neat trick. They do not show us the subject's "inner self," but the flicker of those multiple selves we all inhabit every day. By adopting the conventions of the film still to the portrait photograph, by suppressing the film's narrative and character, Childers portrays performers in costume, *in situ*, but not quite in "character"—like children playing dress up caught, inadvertently, playing themselves. As

ABOVE *Natalie Wood at MGM studio, Hollywood,* 1972, gelatin silver print

ABOVE RIGHT *Raquel Welch,* gelatin silver print

a consequence, there is genuine pathos in these photographs. The dissonance between the performer and the accoutrements of performance provides us with glimpses of people, who, being performers, are never not performing, leaving us to ask if we ourselves are ever not performing.

Two other sets of Childers' photographs (I call them the "guy" pictures and the "diva" pictures.) are similarly grounded in the assumption that performers always perform. In these photographs, the subjects are allowed to perform their ideal selves: the "exquisite diva" and the "regular guy." Jacqueline Bisset, Michelle Pfeiffer, Raquel Welch, Mary Ellen Mark, Julie Christie, and Natalie Wood all embody the exquisite divas of their own imagination, their own idea of what we want to see. In this category, the photographs of Natalie Wood are the most telling. Even the semi-casual photograph of Wood on a film set from 1972 captures her in full diva mode, and we understand from these pictures that Wood was rarely, if ever, not "Natalie Wood." Richard Gere, Ringo Starr, Rod Stewart, Mel Gibson, Dustin Hoffman, Clint Eastwood, and Rock Hudson all do their best to be "regular guys," and even when they fail to convince us, as Rock Hudson, in his sweet discomfort, does, there is something charming, if patently delusional, in their aspiration.

My point here is that none of the pictures actually convince us that we are seeing the "real" subject, nor are they designed to. Even so, they succeed, as Warhol films do, by failing to convince us, and they seem more "real" as a consequence. The pretense of perfect candor leaves nothing to the imagination, perfect artifice does. What, after all, could be more "real" than Warhol super star, Joe Dallesandro, perfectly in character, playing the diva with his hair afloat (*p. 35*), or Lily Tomlin, at ease on the beach, playing the winsome regular guy. These "roles," like Mitchum's gun, are clearly props, prostheses, and the clarity of their artifice is ultimately poignant. We infer the size of the wound from the size of the bandage, just as we do with Childers' more traditional Renaissance-style "portraits with attributes." We see George Cukor in his study with his Georges Braque still life, George Hurrell with his camera in front of his image of Marlene Dietrich (*p. 33*), Ultra

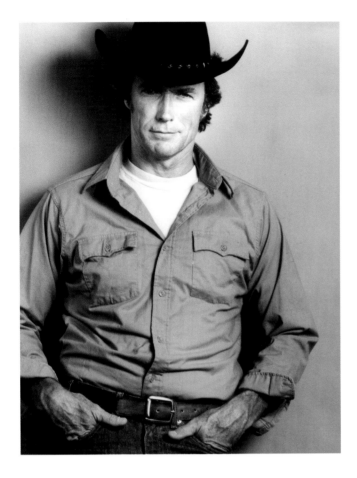

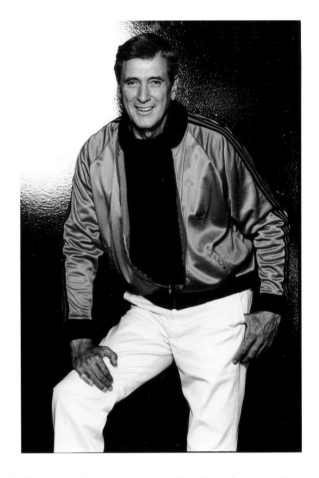

ABOVE *Clint Eastwood,*
Hollywood, 1982, toned gelatin
silver print

ABOVE RIGHT *Rock Hudson,*
Hollywood, 1984, toned gelatin
silver print

This photograph was taken at the
time Rock Hudson became ill
with AIDS. His illness progressed
quickly, and he died about nine
months later at the age of 59.
Hudson was the first major figure
to openly acknowledge that he
was suffering from the disease.
His openness helped focus
greater attention on the AIDS
epidemic and a search for a cure.

Violet in bed, leaning on a Roy Lichtenstein banner and covered with an American flag
(*p. 30*) and recognize the truth in these elaborately constructed fictions.

The key to the effectiveness of Michael Childers' photographs, then, is that they presume the cultural and pictorial conventions of making pictures have their own reality. The "diva" portrait, the "actor in costume" shot, the "portrait with attributes," the "head shot" etc., are presumed to be as real as the people and objects portrayed in these genres. Each genre tells its own truth and exists in a live relationship with the conventions of our everyday living. As Warhol would have it, Childers presumes that in a democracy, we are always on stage, always performing and handling props and that the camera is always there as we play our numerous, disjunctive roles. We are parents, children, professionals, customers, colleagues, friends, and lovers, and the camera is always on, even in the intimacy of our closest relationships.

The sweetest examples of this presumption and the most telling groups of photographs in the exhibition are the suites of images Childers has taken of his two iconic friends, Andy Warhol and David Hockney, performing in private (*pp. 44–45*). Neither Warhol nor Hockney, of course, qualify as public performers. They are officially artists and, temperamentally, directors who tell others how to perform. Childers allows them to act themselves out. With this permission, the publicly aloof and cliquish Hockney reveals himself as his friends know him, as the antic nine-year-old at play in the world, as the enthusiastic kid with the frog in his pocket. Warhol, on the other hand, who is invariably pictured in groups and crowds, who lived in groups and crowds, is portrayed as his friends saw him, as the loneliest, most solitary, man in the world, alone in a large room, dressed up for the party that may or may not happen. Neither of these portrayals captures the "real" creature, of course. Nor do they reveal any terrible secrets. They do, however, capture Hockney and Warhol in roles that presume an unusual level of affection and intimacy. In doing so, they add to the repertoire of roles in which we know them and complicate our knowledge. No subject of a photograph could wish for more.

60 *Double Dora*, 2001, gelatin silver print

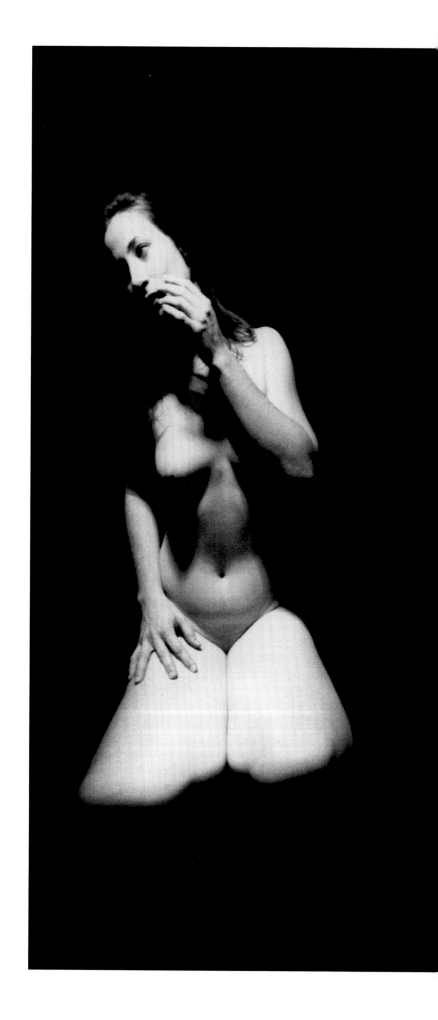

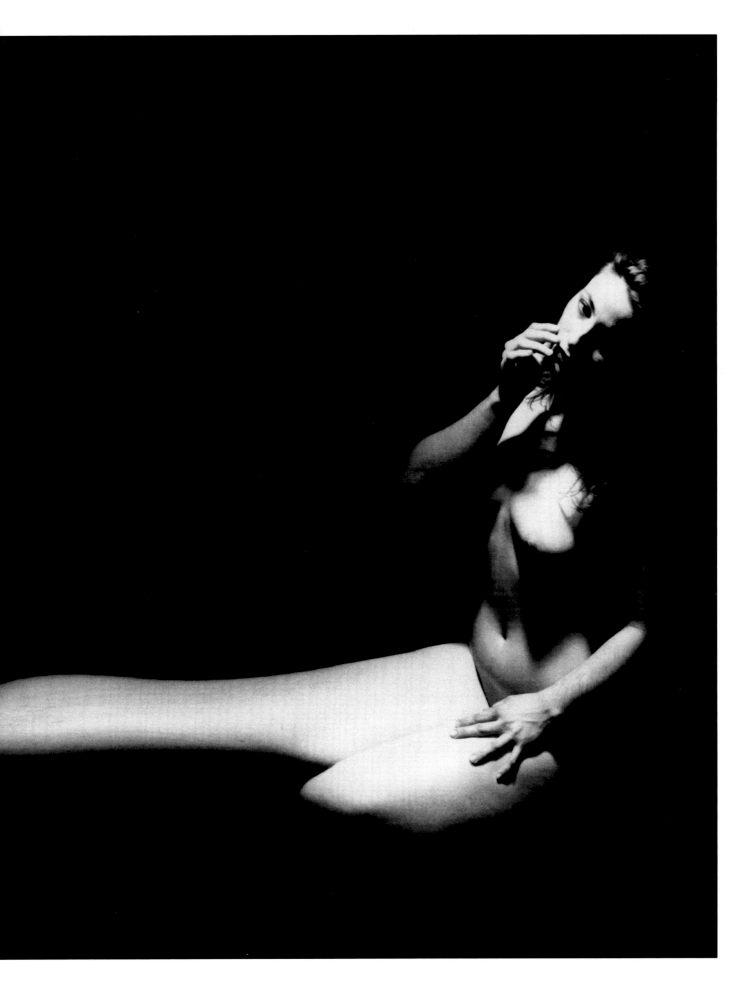

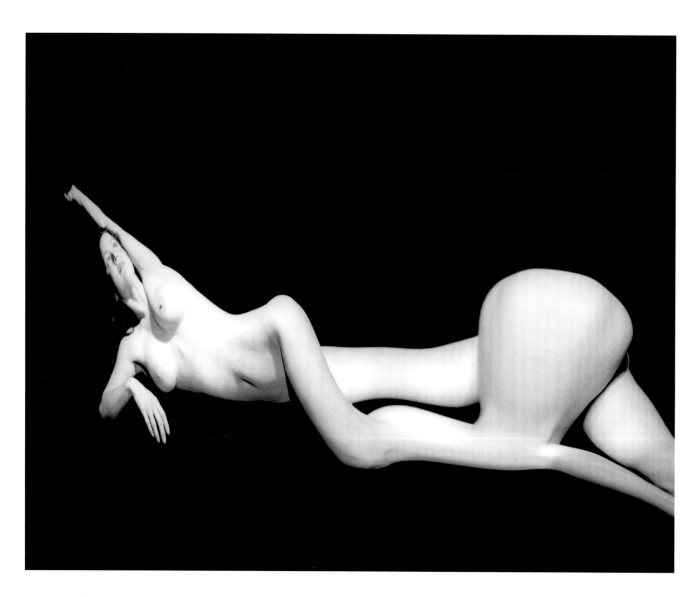

Reclining Nude, 2001, Iris print

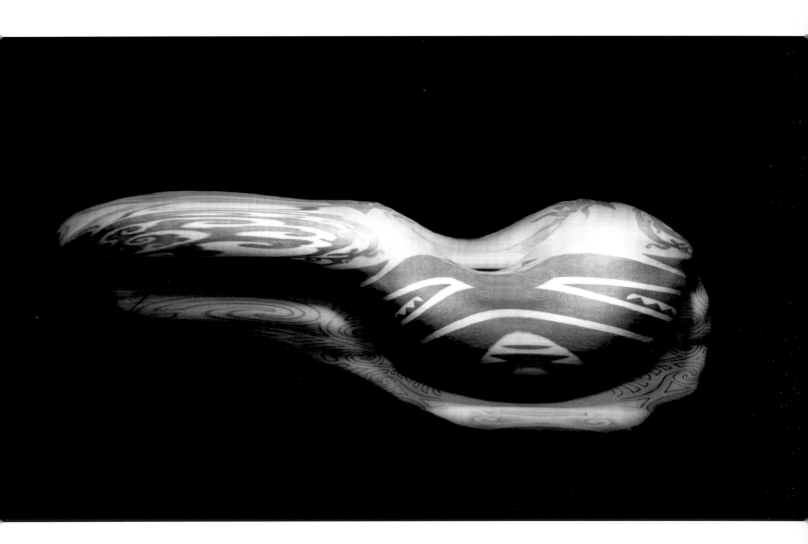

Coquille, 2001, Iris print

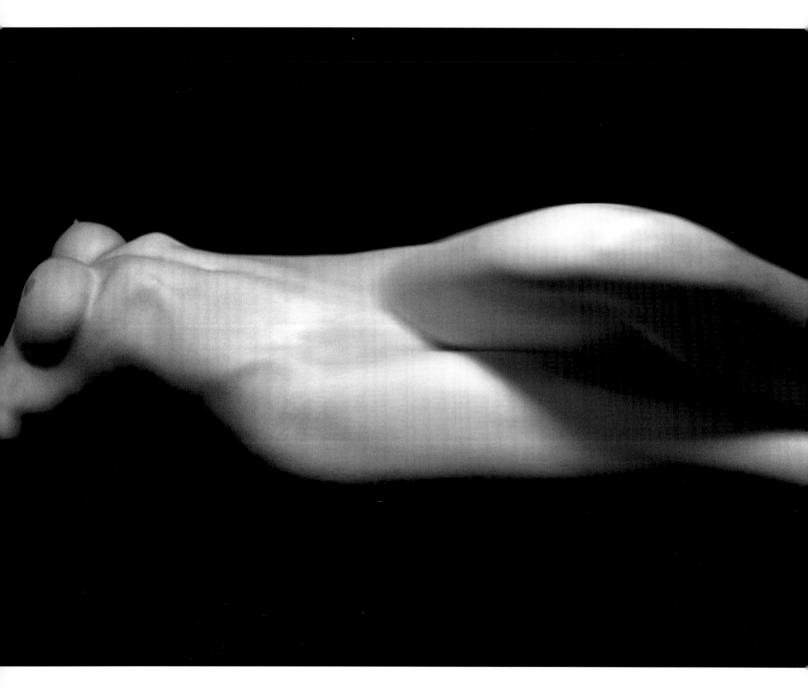

Venus in Landscape, 2001, Iris print

OPPOSITE *Tattooed Torso*, 2001, Iris print

Emergence from the series "Passionate Moves," 1999, Iris print

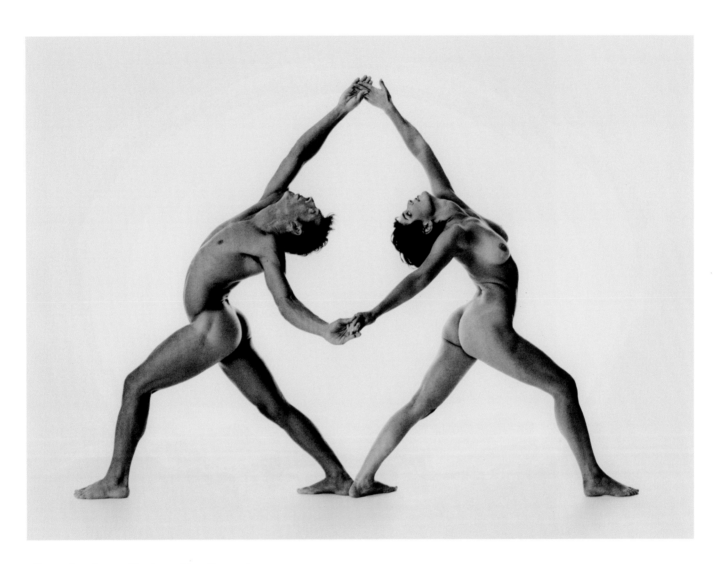

Oneness from the series "Passionate Moves," 1999, Iris print

68 ABOVE *Lesley-Anne Down for "British Vogue,"* 1980, toned gelatin silver print

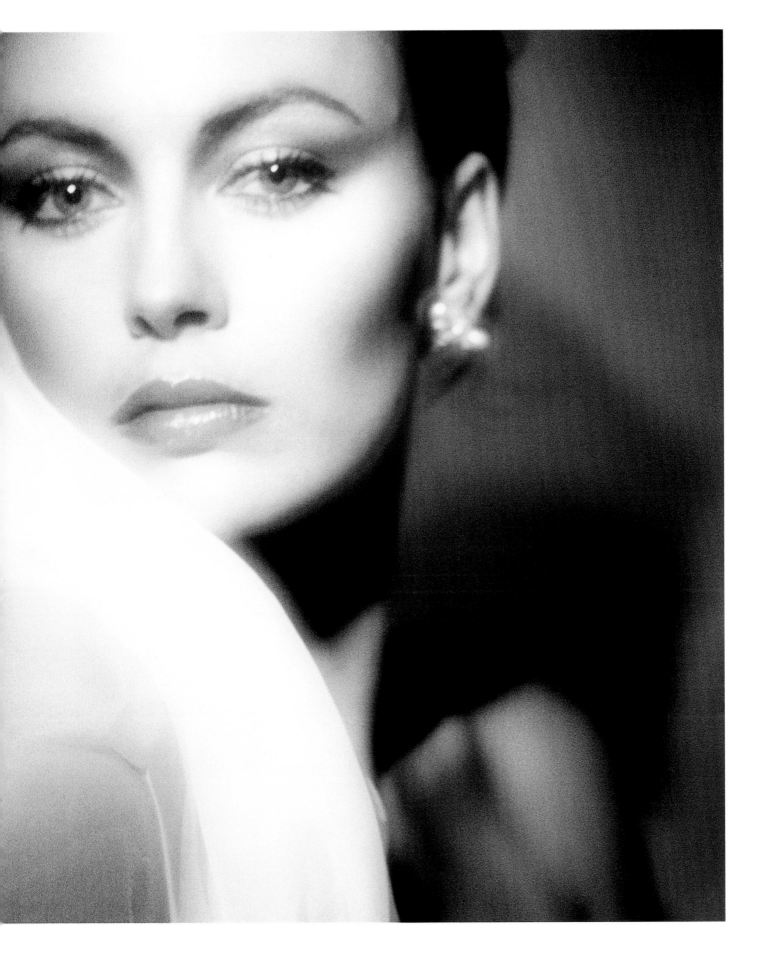

ABOVE *Jennifer Bartlett, Palm Springs, CA,* 2005

OPPOSITE *Michelle Pfeiffer, Hollywood,* 1982, toned silver print

PAGE 74 and 75 *Ann-Margret, Palm Springs, CA, 2009*

OPPOSITE *Kenneth Anger, Hollywood, CA, 1982*

BELOW *Henry Rollins, Hollywood, CA, 2000*

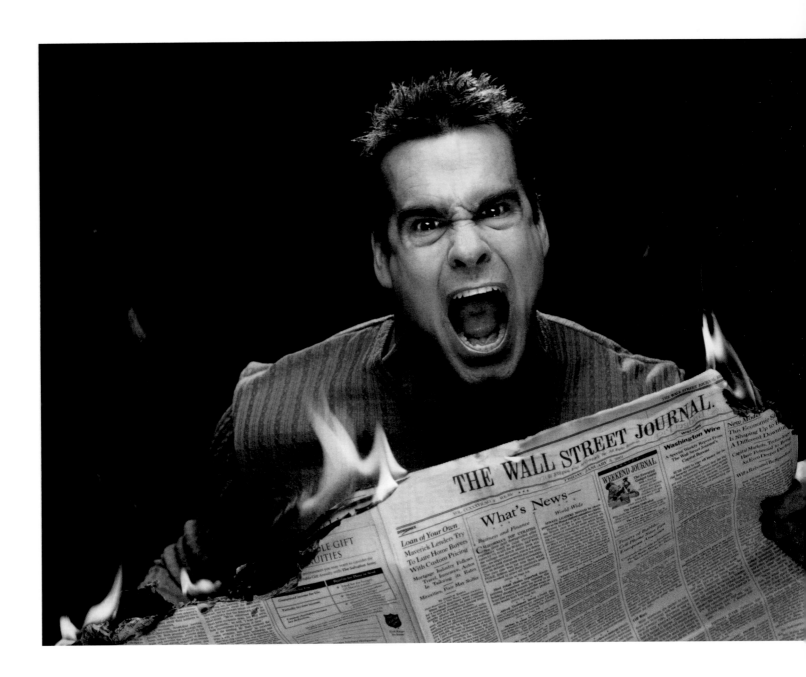

ABOVE *Ed Ruscha, (at his studio) Venice, CA,* 2005

OPPOSITE *Julius Shulman, Hollywood, CA,* 2001

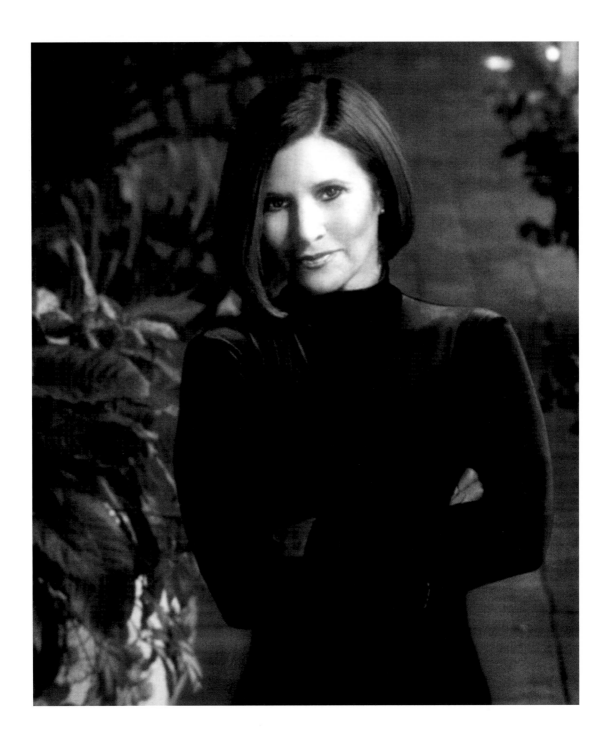

RIGHT *Amy Tan, Sausalito, CA, 2011*

ABOVE *Carrie Fisher, Beverly Hills, CA, 2000*

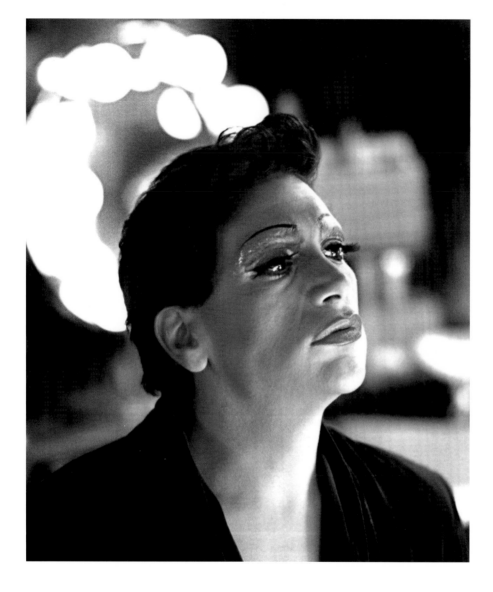

ABOVE *Harvey Fierstein, Hollywood, CA, 1985*

OPPOSITE *Charles Busch, New York, NY, 2011*

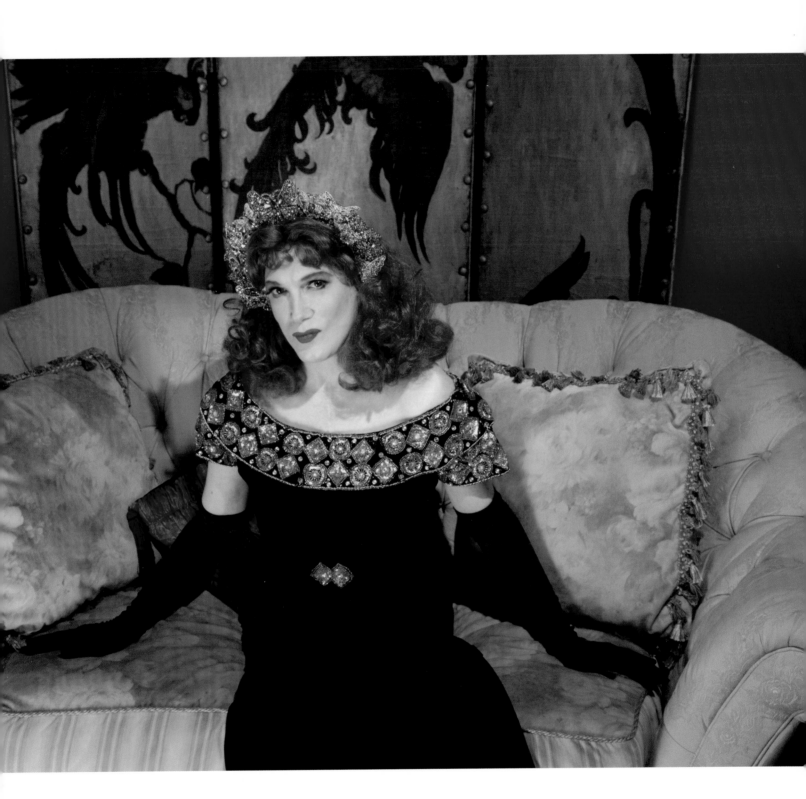

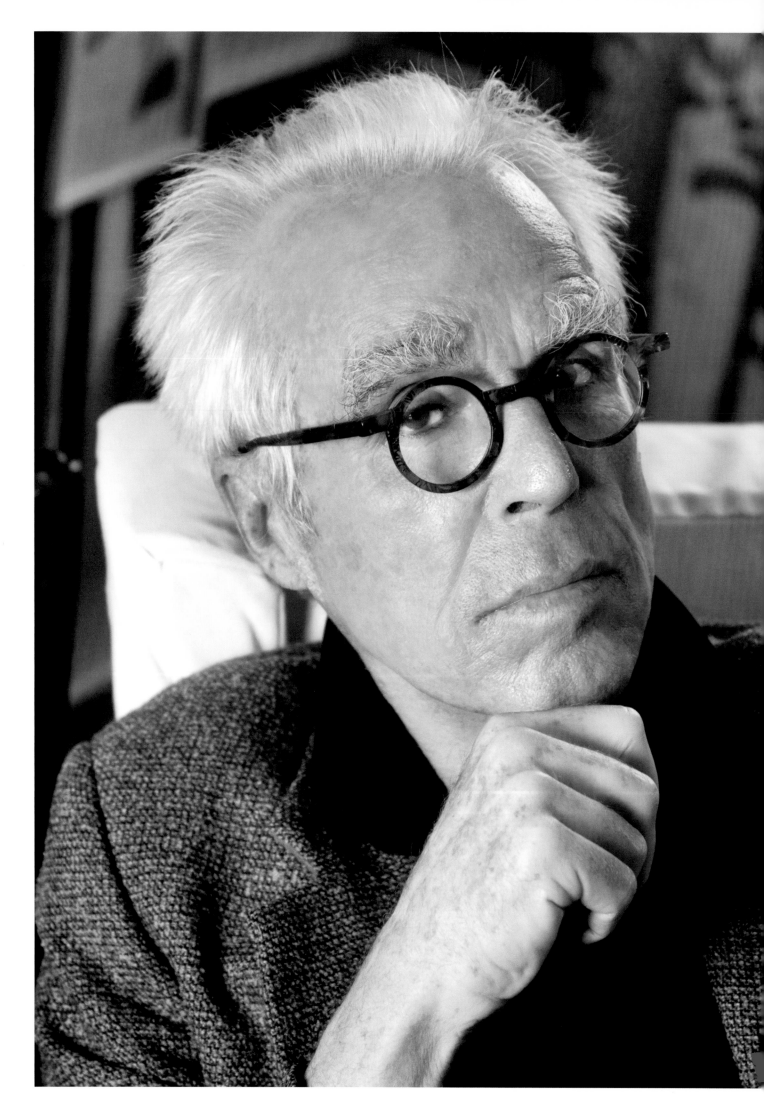

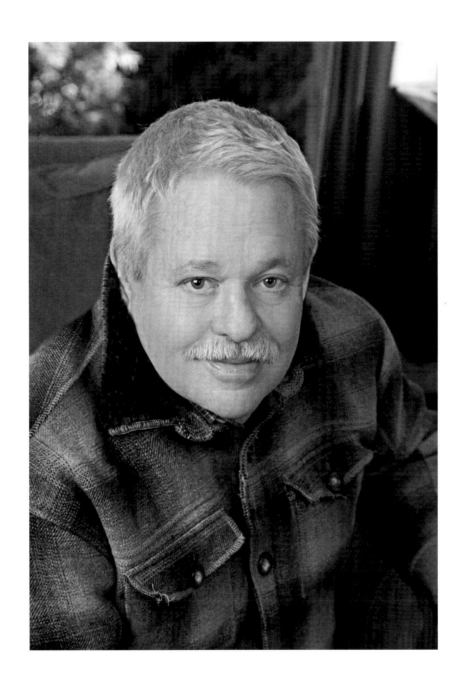

RIGHT *John Guare, New York, NY, 2011*

ABOVE *Armistead Maupin, San Francisco, CA, 2011*

84

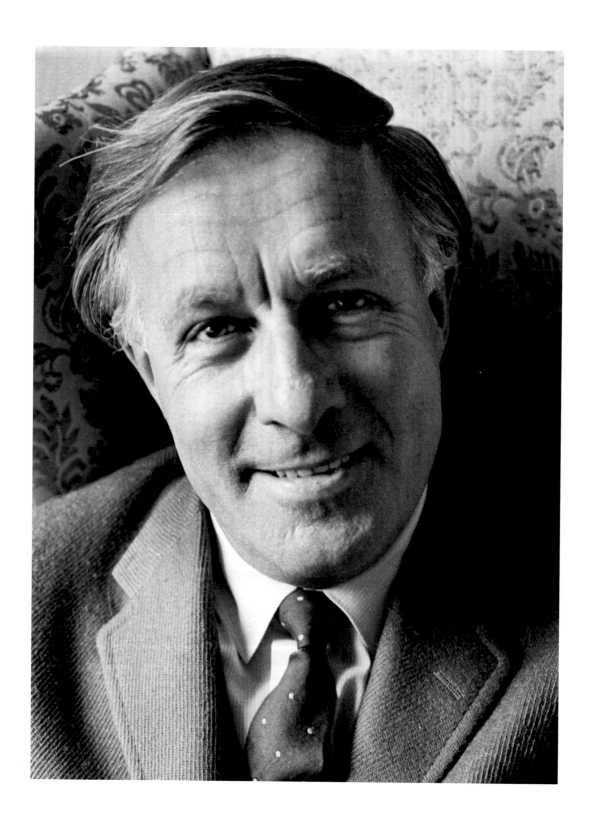

ABOVE *Ray Bradbury, Los Angeles, CA, 1968*

OPPOSITE *Paul Rudnick, New York, NY, 2011*

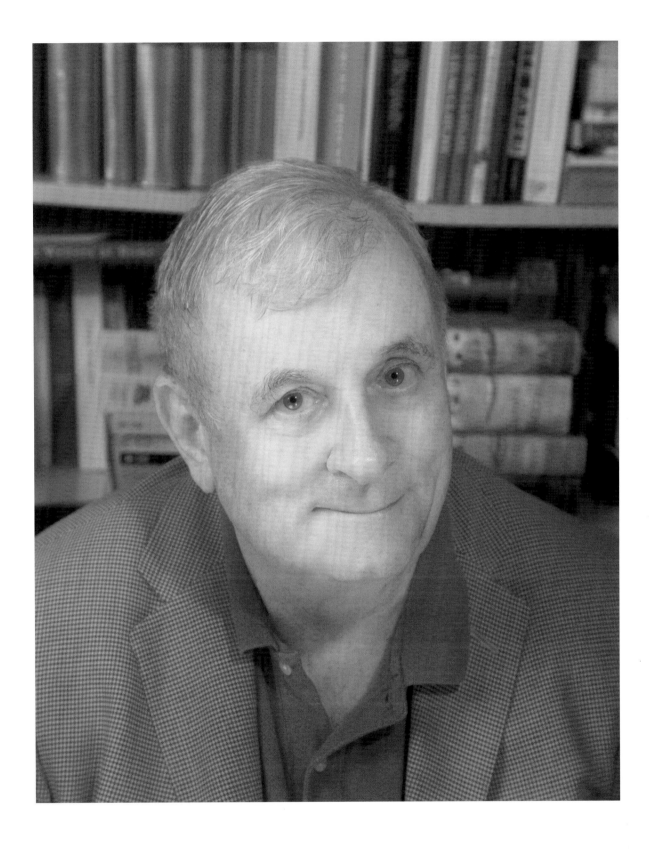

OPPOSITE *Julie Taymor, New York, NY, 2012*

ABOVE *Edmund White, New York, NY, 2012*

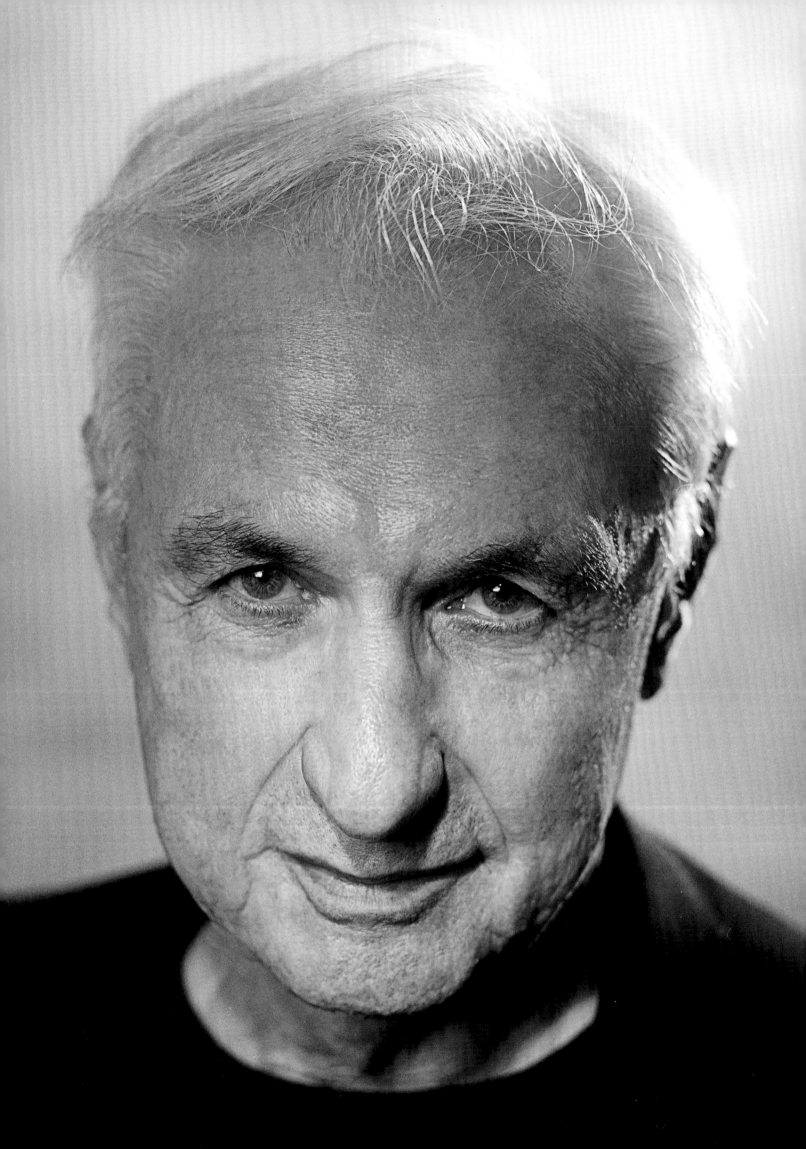

RIGHT *Frank Gebry, Venice, CA, 2005*

ABOVE *Dennis Hopper, Venice, CA, 2005*

ABOVE *Donna Summer, L'Hotel, Paris, France, 1983*

RIGHT *Michael Feinstein, Los Angeles, CA, 1998*

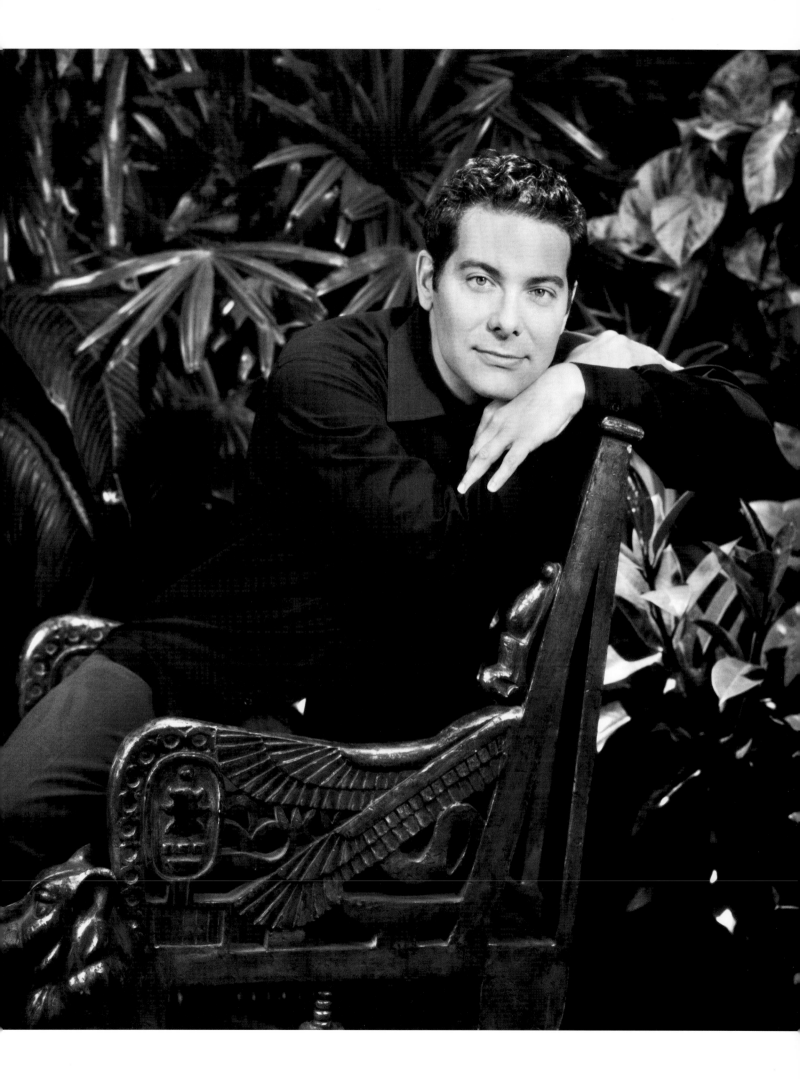

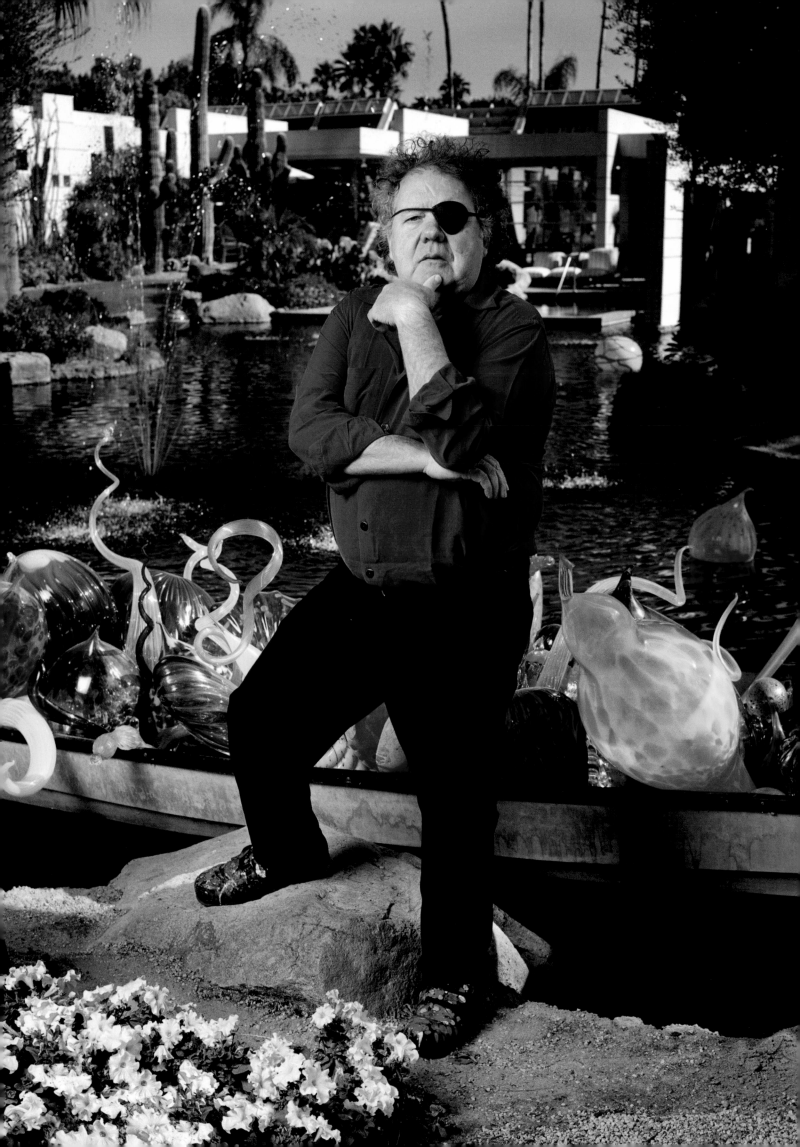

RIGHT *Dale Chihuly, Rancho Mirage, CA, 2002*

ABOVE *Oliver Stone, Los Angeles, CA, 2011*

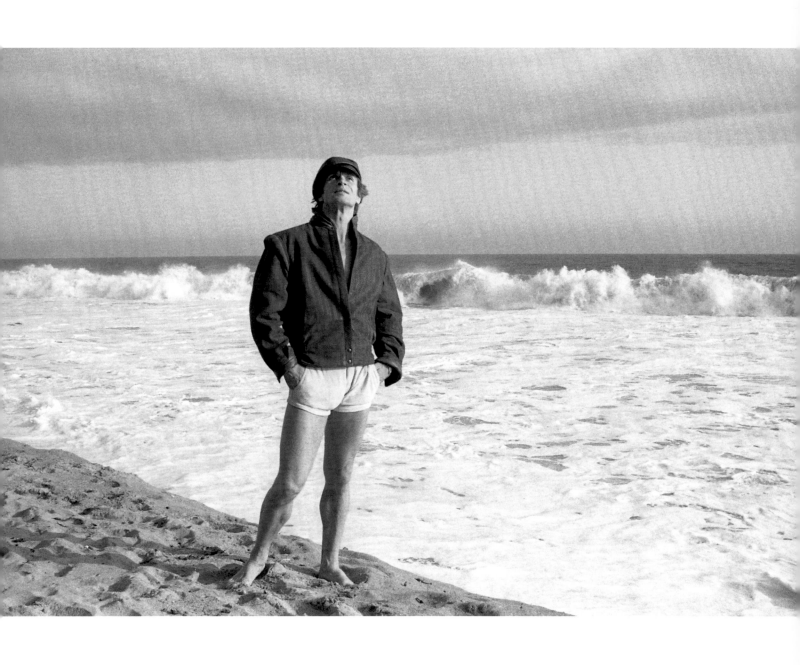

LEFT *Julie Christie, Malibu, CA, 1968*

ABOVE *Rudolph Nureyev, Malibu, CA, 1988*

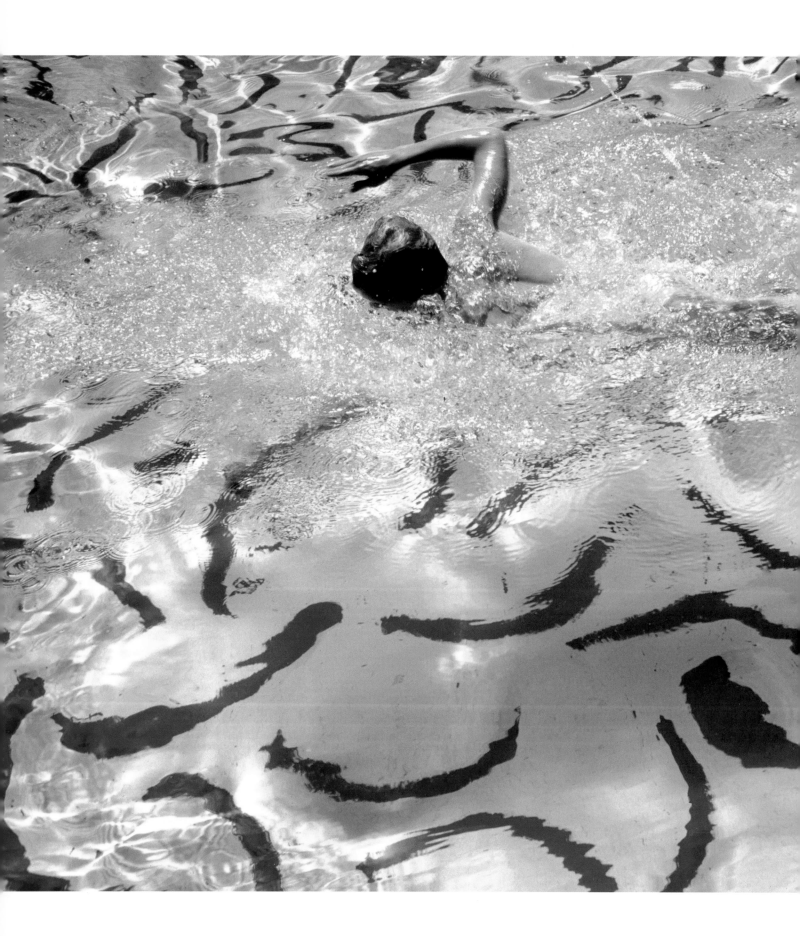

ABOVE *The Hockney Swimmer, Los Angeles, CA, 1978*

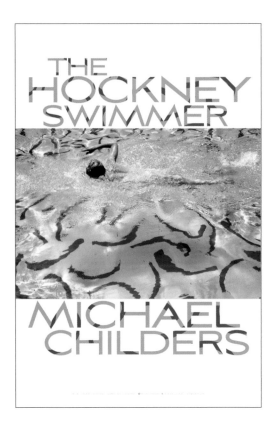

TOP Book Cover: *Backyard Oasis, The Swimming Pool in Southern California Photography*, 1945-1982 © 2011.
Palm Springs Art Museum and Prestel Verlag

BOTTOM *The Hockney Swimmer*, Michael Childers Poster
Poster Design by Stephen Brogdon.

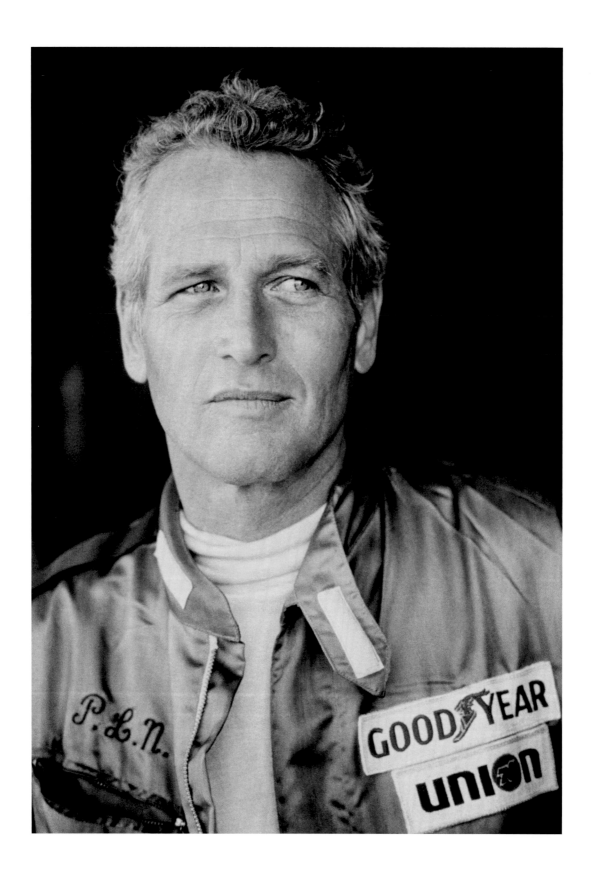

ABOVE *Paul Newman, Hollywood, CA, 1969*

OPPOSITE *Gore Vidal, Los Angeles, CA, 2011*

ABOVE *Dusty Springfield, Los Angeles, CA, 1978*

OPPOSITE *Elton John, London, England, 1970*

PAGES 102-103 *Scott Wittman and Marc Shaiman, New York, NY, 2011*

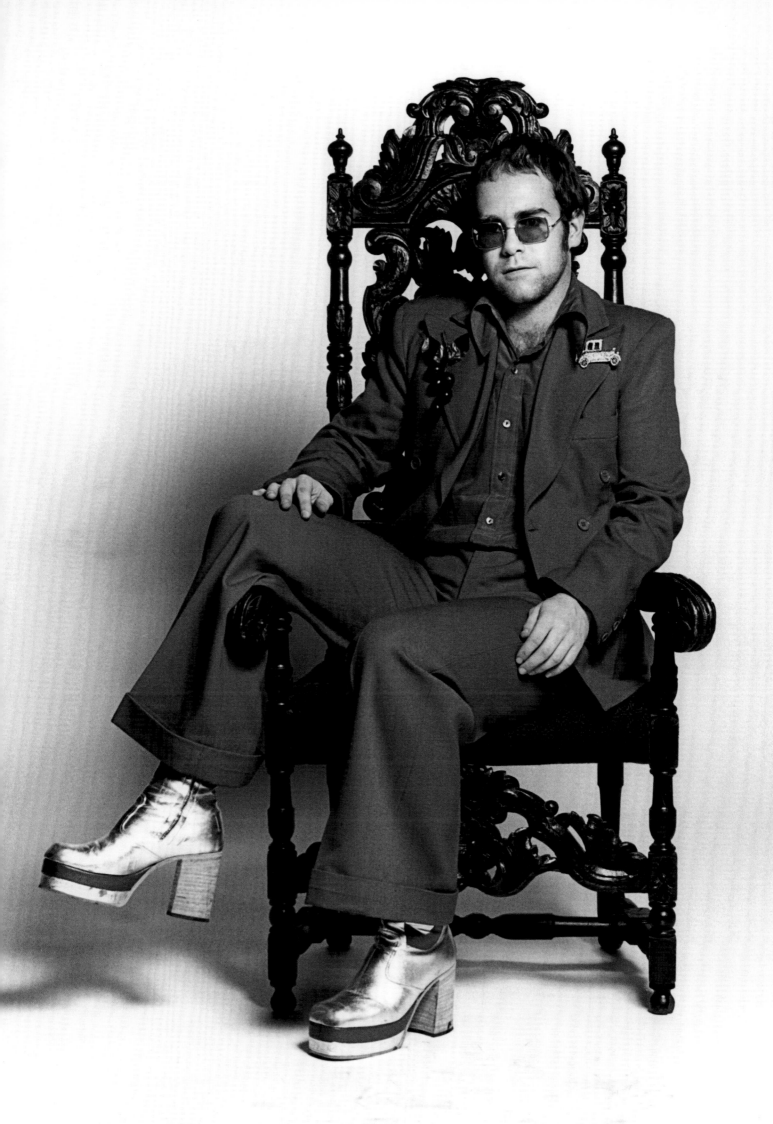

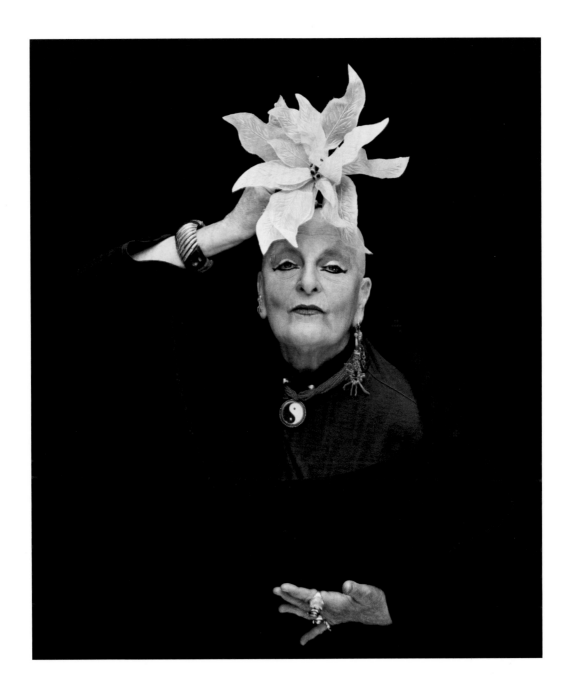

OPPOSITE *Ron Athey, Hollywood, CA, 1999*

ABOVE *Rachel Rosenthal, Hollywood, CA, 2000*

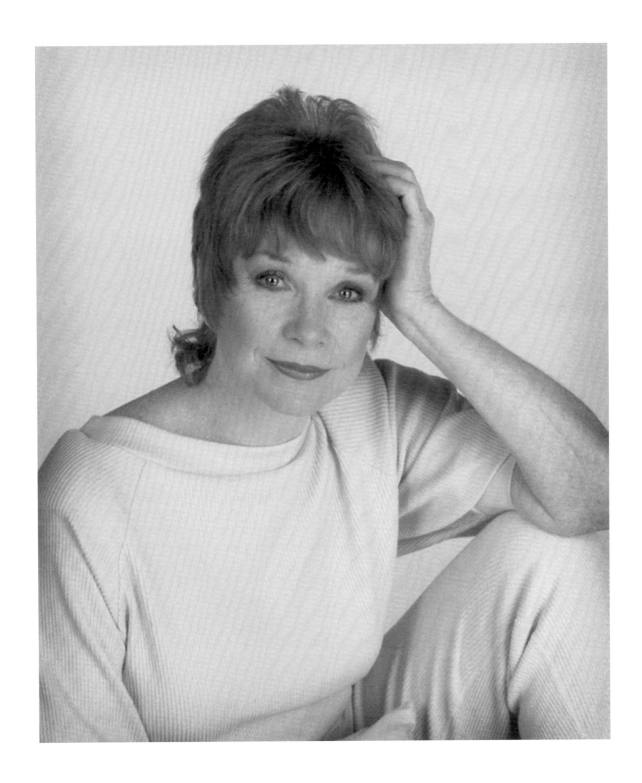

OPPOSITE *Tina Turner, London, England,* 1971

ABOVE *Shirley MacLaine, Hollywood, CA,* 1985

Edward Albee, New York, NY, 2011

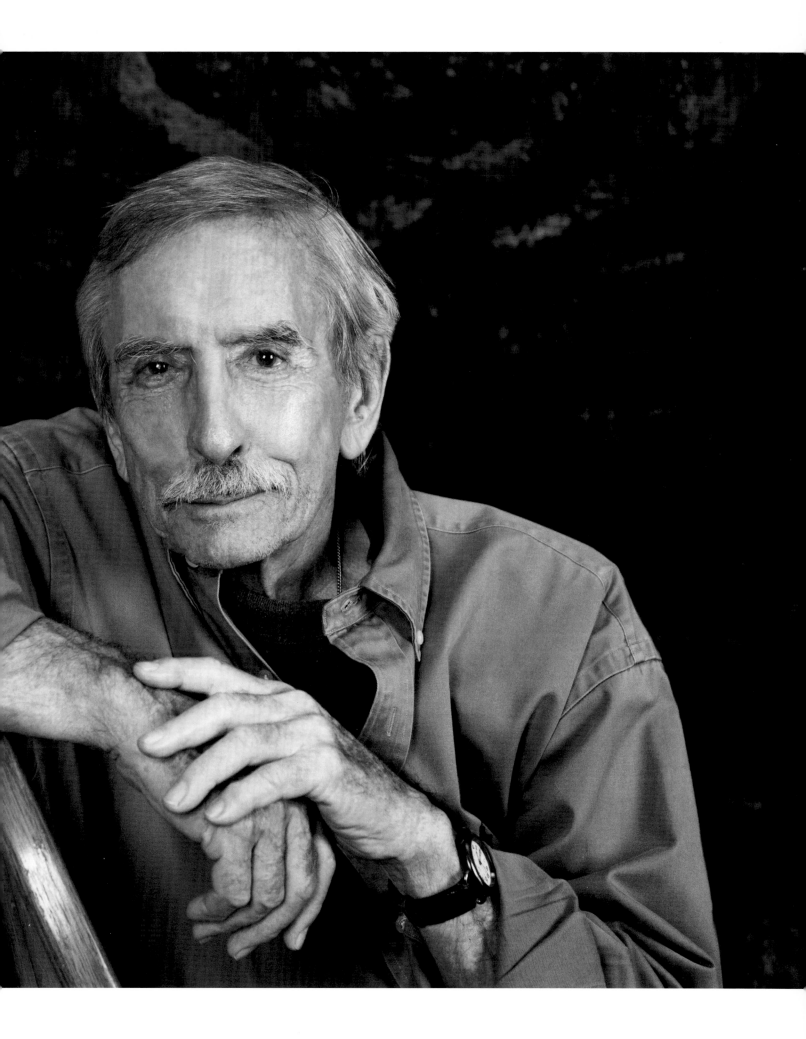

The Glamorous Photography of Michael Childers

Rex Reed

HERE IS QUALITY WORK THAT TURNS PICTURES INTO ART.
Michael Childers has a keen eye, the same sense of pure poetry reflected in a camera lens that great writers use to elevate writing to literature, and a passion for beauty. Back in the day, famous celebrity photographers spent days juggling heavy, expensive and elaborate equipment on inconvenient tripods while working on the planes, contours and symmetry of the human face to achieve the same effects Michael creates with one camera slung over his shoulder like a war correspondent in Iraq.
He's seen it all and puts you in the picture. The result of his take-home artistry is always riveting.
He makes every subject mirror the truth while looking better than they ever looked in their lives.
From the unique rapture of Natalie Wood to the laid-back, unfussy joy of Ann-Margret, the images captured in this collection will haunt you. When he clicks, you stay clicked.
You also look the way you hope you will look forever.

Rex Reed, New York, NY, 2011

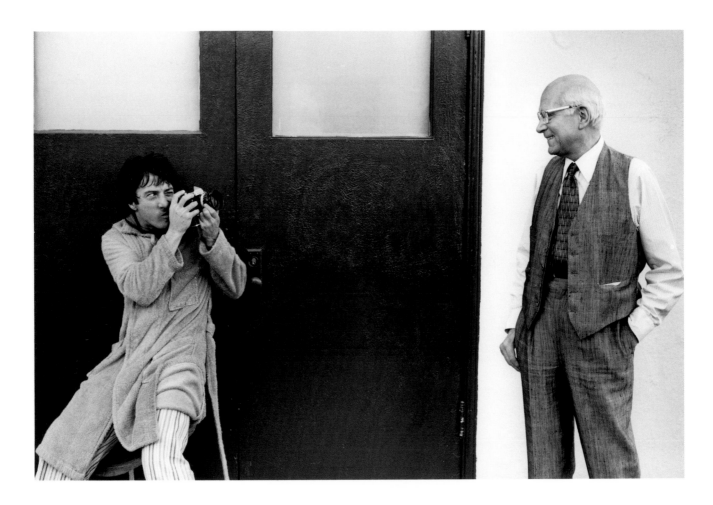

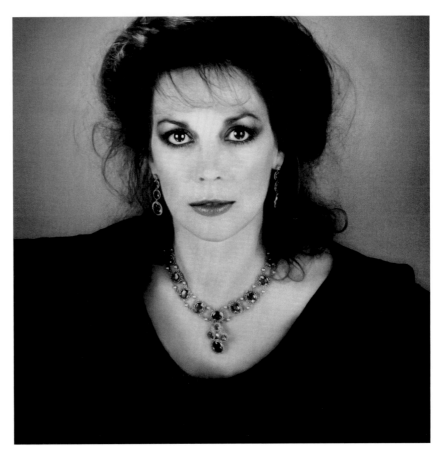

Dustin Hoffman Photographing Sir Laurence Olivier on the set of "Marathon Man," Paramount Studios, Hollywood, 1975, gelatin silver print

Childers captures Hoffman as he photographs his co-star during a break from the filming of *Marathon Man* (1976). Hoffman was known on the set for his antics and somewhat hyper-active personality. In response to Hoffman, Olivier apparently quipped his famous line: "Just learn how to act!"

RIGHT *Natalie Wood as "Anastasia": The Last Portrait,* 1981, toned gelatin silver print

This portrait was taken for the play *Anastasia* scheduled to open at the Ahmanson Theater in Los Angeles. It would have been Wood's first theater performance, but she tragically drowned on Thanksgiving weekend, November 29, 1981. Childers had an appointment scheduled the following week to photograph the star for an upcoming issue of *People* magazine when he received the call about her death.

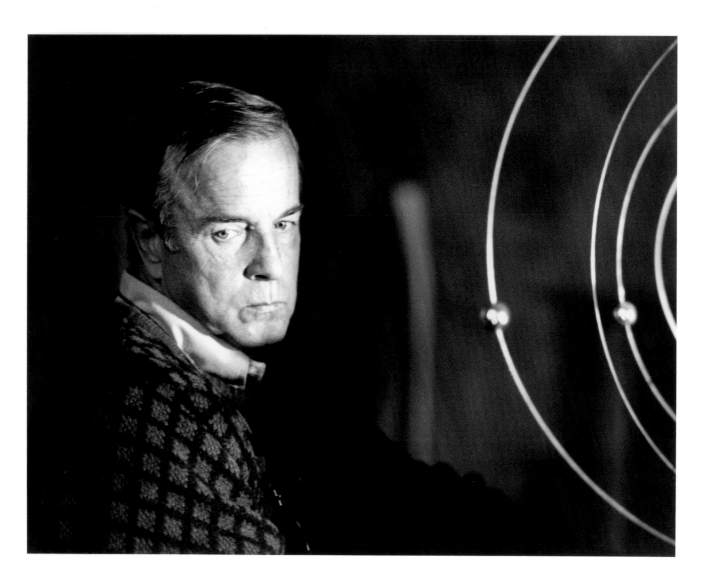

Franco Zeffirelli, New York City, 1981, gelatin silver print

"To Michael Childers: I recently saw your work filled with
so many extraordinary fantasies—I was literally shocked by
the beauty of it all. What you have achieved with these
superb images is absolutely outstanding. Every page is a
revelation, like leaping through a sketch book of
Michelangelo or da Vinci. You have struck the inner core of
my very being and touched me profoundly—I feel deeply
moved by what you have created—indeed overwhelmed."
—Franco Zeffirelli, Rome, Italy, March, 2003.

PAGE 116 *Bette Midler, Hollywood*, 1979, gelatin silver print

Epilogue: Face Value

Dr. Daniell Cornell

Since the 1960s Michael Childers has been photographing famous people within the broad genre of portraiture. His long connection to the world of celebrity has given him access to many of the iconic film stars, theater actors, artists, and writers of our time. However, it would be a mistake to think of Childers under the moniker of celebrity photographer. It is true that some of his photographs were the result of commissions and assignments meant for commercial publication, but the overall tenor of his pictures reaches well beyond the goal of publicity.

It is the job of the celebrity photographer to capture the essence of what gives someone his or her notability. By contrast, the most skillful portrait photographers reveal the inner psychological character of the person, as revealed by their expression and gesture. This is not to say that such images are not posed. In fact, to model or sit for a portrait requires that the sitter assume an attitude, position, or action that will create an effect for the camera. It is this very notion of posing that Childers exploits so insightfully.

As we are reminded in the line from the well-known pop song Vogue, "Strike a pose – there's nothing to it." The ambiguity of that phrase is telling. In one sense, a pose really is "nothing." It is a pretense, a false impression, a surface reflection. However, in another sense, to acknowledge that for all essential purposes the pose is an empty cipher means that what we see in a successful portrait is the content that the artist brings to the photographic session. This is true whether the setting is the studio, outdoors, a fabricated backdrop, or some other cinematic mise-en-scene.

Childers asked me to write this epilogue for his second edition of *Icons and Legends* in part because his photograph, *The Hockney Swimmer, Los Angeles* (1978) has recently received international praise as the signature image in my Pacific Standard Time exhibition, *Backyard Oasis: The Swimming Pool in Southern California Photography* (2012), presented at the Palm Springs Art Museum. Although it may seem like an odd selection for a book devoted to portraits, it reveals several of the key strategies that make Childers' pictures so compelling, beginning with the sly deflection from the person to David Hockney's recognizable pool, which places the subject within a context.

The sunlit pool, with the swimmer's lithe, athletic, young body speaks to an entire milieu associated with the bohemian life of artists, actors, and writers in Los Angeles. Hockney's painted pattern on the bottom of the pool references his paintings and links this scene to the history of painters interested in capturing the effects of light. In this manner it also signals Hockney's longstanding engagement with the relation between photography and painting. The pool's arabesque-like painted marks mirror the fluid movements of the swimmer, recalling Henri Matisse and the aesthetic history of experimentation with pattern, color, and line that he introduced, and which Hockney continues. In addition, Childers' photograph uses the reflections on the water to remind viewers that photography relies first and foremost on a vocabulary of light. The result is a photographic portrait that is as much about time, place, and artistry as the person depicted; an acquaintance that Childers knows but chooses not to name, letting him be both subject and lexical referent.

This photograph, from his good friend Hockney's backyard pool, is also a reminder that Childers usually photographs from a position of friendship. Such relationships account for his ability to convey the multiple facets of personality that transcend the roles for which most of his sitters are known. Friendship, that most generous of relationships, opens his sitters up to an exchange through Childers' camera lens and allows viewers to enter into the scene he has conjured. And even though I am not famous in the manner of most of his sitters, I am pleased to call Michael a friend and privileged to be drawn into his world through these photographic portraits.

Selected Bibliography

Baldwin, Gordon. *Looking at Photographs: A Guide to Technical Terms*. Los Angeles: The J. Paul
 Getty Museum, 1991.

Britton, Jeff. "Childers' Work Has Theatrical Dash." *The Desert Sun*, 28 April 2002, E1.

Childers, Michael. *Michael Childers: Biography*. Michael Childers Photography.
 www.michaelchildersphotography.com. 26 February 2003.

Elle (French Issue). September 1981. Cover photograph of Catherine Deneuve by
 Michael Childers.

Hockney, David. *David Hockney On Photography*. New York: André Emmerich Gallery,
 Inc., lecture given November 1983.

Jorgensen, Jay. "Michael Childers: The Time of His Life." *Petersen's PHOTOgraphic*, March
 2001, pp. 42-45.

Katzman, Louise. *Photography in California: 1945–1980*. New York: The San Francisco
 Museum of Modern Art, 1984. (exhibition catalog)

Lebrun, Dominique. *Hollywood*. Spain: Gingko Press Inc., 1996.

Maltin, Leonard, ed. *Leonard Maltin's Movie Encyclopedia*. New York: Penguin Books USA
 Inc., 1994.

Mann, William J. "Legendary Lensman." *Genre Magazine*, April 2002.

Michael Childers, interviews by the author, Palm Springs, California, 2 July 2003 and
 Palm Springs Desert Museum, 15 July 2003.

Mora, Gilles. *Photo Speak: A Guide to the Ideas, Movements, and Techniques of Photography 1839 to
 the Present*. New York: Abbeville Press, 1998.

Newhall, Beaumont. *The History of Photography from 1839 to the Present*. New York: The
 Museum of Modern Art, New York, 1982.

New York CUE. 14 September 1979. Cover photograph of Al Pacino by Michael Childers.

Plays and Players. January 1973. Cover photograph of Gary Bond in "Joseph and The
 Amazing Technicolor Dreamcoat" and photographs of "Hair," by Michael Childers
 pp. 37-39.

Rolling Stone Magazine. 30 April 1981. Cover photograph of Ringo Starr by Michael
 Childers.

Rosenblum, Naomi. *A World History of Photography*. New York: Abbeville Press, 1997.

Szarkowski, John. *The Photographer's Eye*. New York: The Museum of Modern Art, New
 York, 1966.

Vieira, Mark A. *Hurrell's Hollywood Portraits: The Chapman Collection*. New York: Harry H.
 Abrams, Inc., 1997.

Warhol, Andy. *The Philosophy of Andy Warhol: from A to B and Back Again*. first published in
 1975.

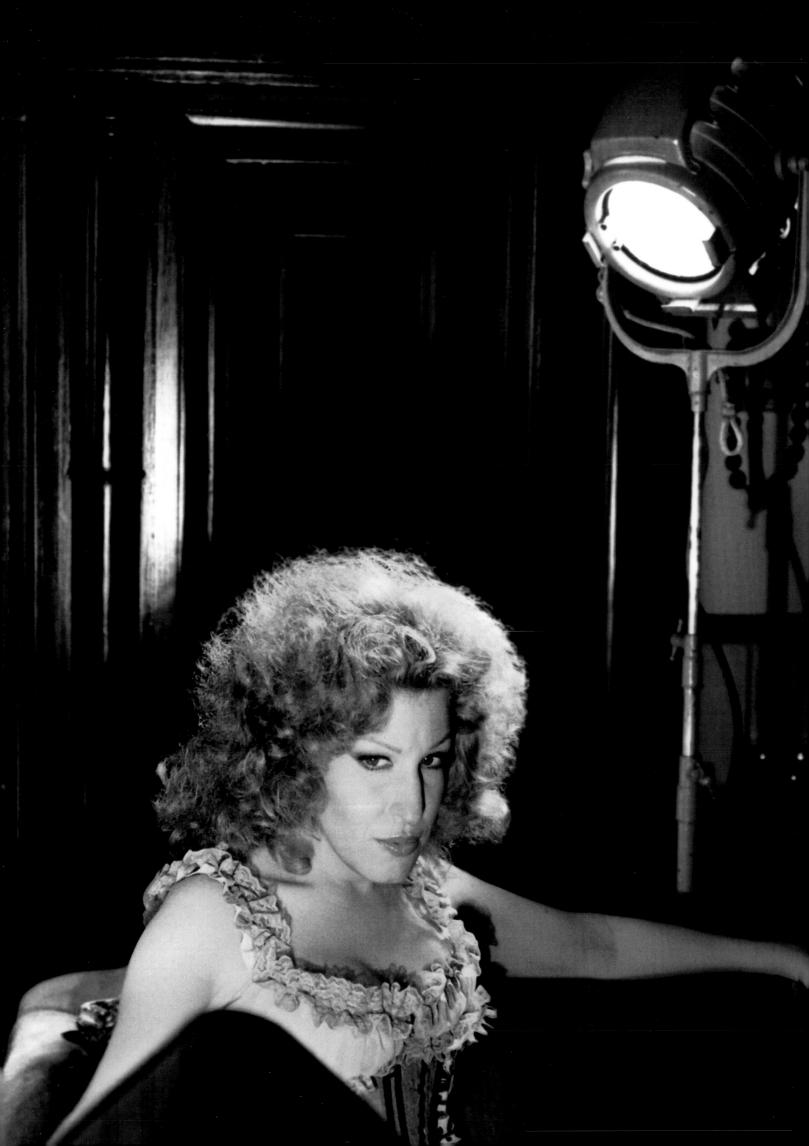